IMAGES
of England

AROUND
YARMOUTH, TOTLAND
AND FRESHWATER

IMAGES
of England

AROUND
YARMOUTH, TOTLAND
AND FRESHWATER

Compiled by
Anthony Mitchell
and
Olive Mitchell

TEMPUS

First published 1998
Copyright © Anthony and Olive Mitchell, 1998

Tempus Publishing Limited
The Mill, Brimscombe Port,
Stroud, Gloucestershire, GL5 2QG

ISBN 0 7524 1129 2

Typesetting and origination by
Tempus Publishing Limited
Printed in Great Britain by
Midway Clark Printing, Wiltshire

Contents

Acknowledgements 6

Introduction 7

1. Yarmouth – Port of Entry 9

2. Totland and Alum Bay 27

3. The History Makers 37

4. Traders and Toilers 55

5. Land and Sea 81

6. Transport 97

7. Living and Learning 115

Acknowledgements

The authors especially wish to thank the chief archivist and his staff at the Isle of Wight Record Office for their help and co-operation in permitting the use of pictures.

We also thank the staff of the Hampshire Records Office for permitting the use of pictures, especially some from the famous collection of the Hampshire Field Club.

Thanks are also due to numerous members of the Tennyson Society for their advice, particularly the present Mr Hallam Tennyson, for his permission to include May Prinsep. We are grateful for the help of many friendly residents of Freshwater, especially Mr Eric Toogood, who let us use several items from his collection. Lastly, we must apologise if we have missed out any source which we have inadvertently failed to acknowledge.

Introduction

At the western extremity of the Isle of Wight is the peninsular that is sometimes called The Isle of Freshwater or West Wight. It is almost completely cut off from the rest of the island by the Yar Estuary, at the mouth of which lies Yarmouth. Dominating the scene are the spectacular chalk ridges of Freshwater Down (also called Tennyson's Down, or High Down) and the Afton Down. These chalk strata run right across the island, to terminate near Bembridge at the eastern point. Separating the Freshwater and Afton Downs is the gap known as Freshwater Gate or Freshwater Bay. It is here, in a stretch of low-lying marshland, only a few yards from the English Channel, where a fresh-water streamlet, that gives its name to the nearby village of Freshwater, rises and starts its flow northwards, meeting the tidal estuary of the Yar to flow into the Solent.

The name Yar comes from the Anglo-Saxon word 'Ermud', which means muddy estuary. For centuries, the only connection between West Wight and the rest of the island was a causeway carrying the lane between Afton Farm and the old village of Freshwater, crossing the Yar at about the point where it becomes tidal. Archaelogists inform us that the island has been peopled by Celts, then ruled by Romans (who called it 'Vectis' – being the Latin form of 'Wight', which comes from the Celtic word 'Guith', meaning a separation).

According to the *History of the Isle of Wight* by J. Albin, the parish of Freshwater, by the eighteenth century, covered six manors. These were Afton, Compton and Wilmingham, on the east side of the Yar, and on the west side the manors of Kings Freshwater, Priors Freshwater and Western Brayboeuf. Kings Freshwater held general court leet for Priors Freshwater and Weston which, in their turn, drew tribute from the farms and hamlets of Norton, Eastern, Middleton, Weston and Sutton. The last-named was later absorbed into Freshwater Gate and has ceased to exist as a separate entity. These six hamlets comprised the nuclei of the community of Freshwater.

A few cottages clustered in the vicinity of the parish church of All Saints (according to Venables' *Guide to the Isle of Wight*), were the only habitations in what could be described as Freshwater village until about 1860. Then, with the coming of Queen Victoria to Osborne and Tennyson to Farringford, the place acquired world-wide fame and, by reason of the influx of well-to-do seeking the bracing climate and the attractions of the sea-shores, the population doubled within a space of about thirty years. Local people found employment as servants, grooms, gardeners and laundresses. The businesses of local tradespeople flourished, and many family firms, such as the Orchards and the Plumbleys, carry on to this day.

In spite of modernisation and considerable urbanisation, West Wight still preserves its unique identity, a fact that is amply portrayed in the following pages of this book.

One
Yarmouth – Port
of Entry

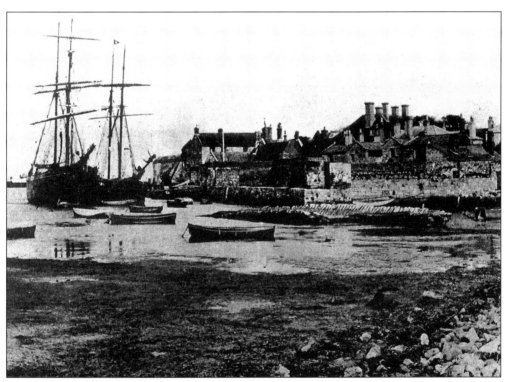

The Harbour, Yarmouth. This is the main port of entry for West Wight, and its chief interest for the traveller is its great variety of shipping, yachts and other small craft.

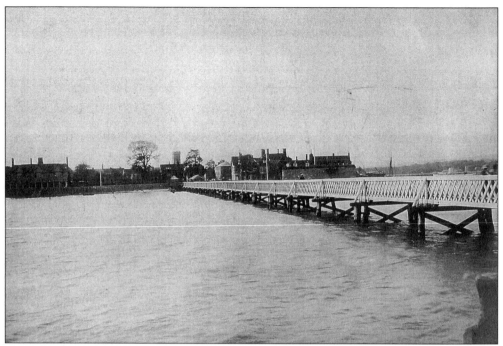

Yarmouth from the head of the pier, c. 1912. The castle can be seen to the right of the picture. The pier was built between 1874 and 1876, at a cost of £4,000, and is one of only two wooden piers surviving in the country.

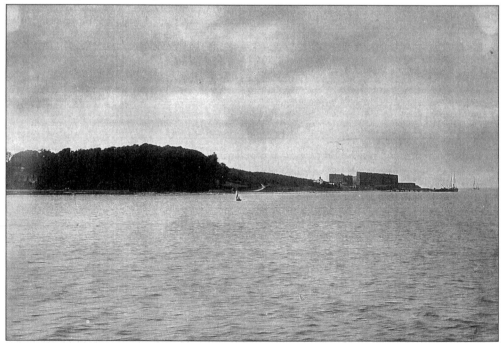

Fort Victoria, one of the Lord Palmerston's defences against threats of invasion from across the English Channel, built during the nineteenth century. Many of these forts have now become theme parks.

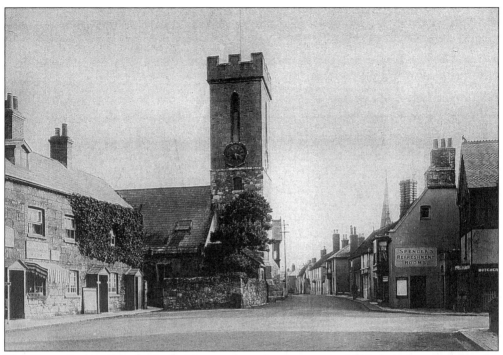

The Town Square, Yarmouth, looking southwards, as it was in 1912. It is dominated by the tower of St James's church.

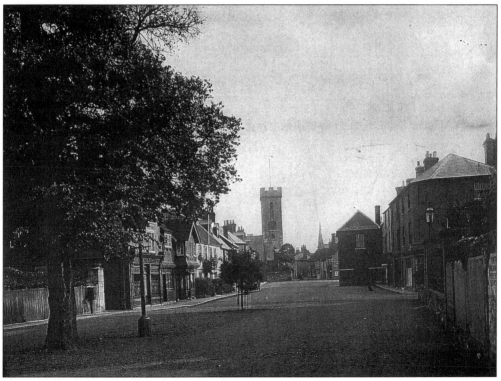

The same view, c. 1923.

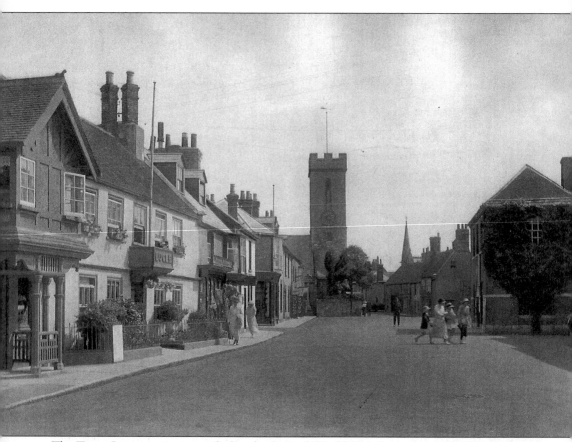

The Town Square as it appeared after the Second World War. It is noteworthy that the tree in front of the church has retained its shape.

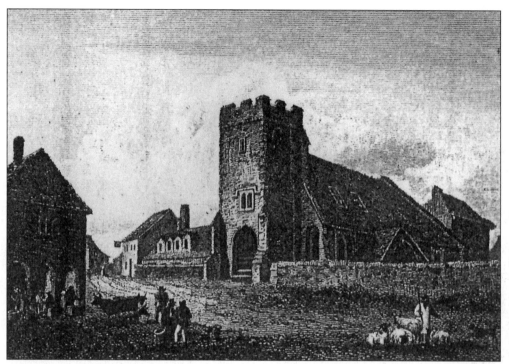

An engraving of Yarmouth church, from a drawing by I. Hassell (date uncertain). It shows the original church tower before enlargement.

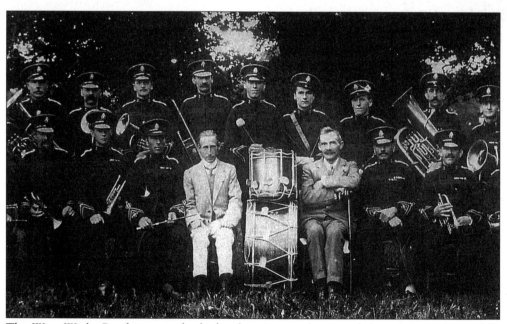

The West Wight Band – a popular body of musicians who provided music at various public festivals and functions throughout Freshwater and Yarmouth during the 1920s and 1930s. The bandmaster at one time was a Mr Watts.

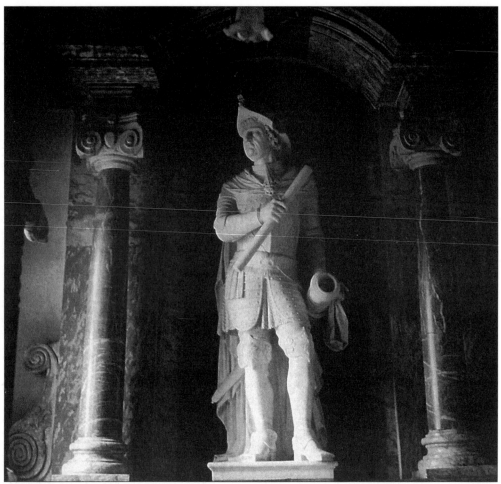

Memorial to Sir Robert Holmes, Governor of the Isle of Wight from 1669 until 1692. A fearless naval commander, he captured New Amsterdam from the Dutch, re-naming it New York. This statue was seized from a French ship and his own sculptured head was affixed to it, hence its disproportionate size.

The east gate of the castle, with the Royal Arms above it. The castle was built with stones taken from Quarr Abbey near Ryde, following its dissolution under Henry VIII.

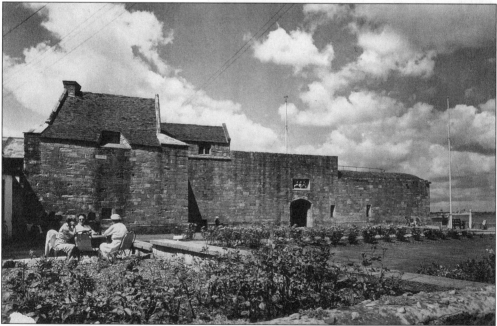

Yarmouth Castle, built by Henry VIII to counter invasion by the French and Spanish in 1545. It was one of three, the others being at Cowes and St Helens. These strongholds proved their worth when the Armada threatened during the reign of Elizabeth I.

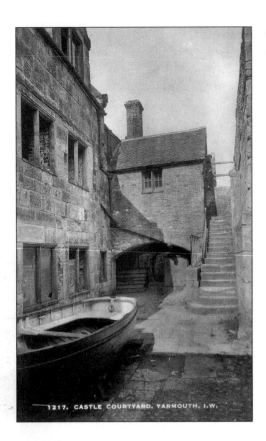

The courtyard of the castle. The boat is dry-docked.

1217. CASTLE COURTYARD, YARMOUTH, I.W.

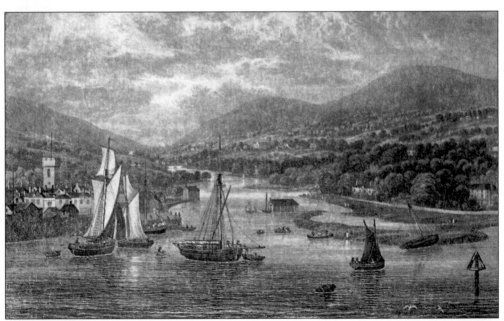

A fanciful impression of the harbour mouth – one of George Brannon's idealised versions of the island's scenery.

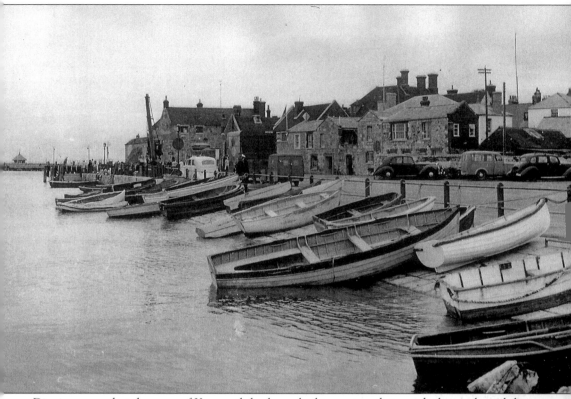

Dingies moored at the quay of Yarmouth harbour, looking seawards towards the castle and the pier beyond, *c.* 1950.

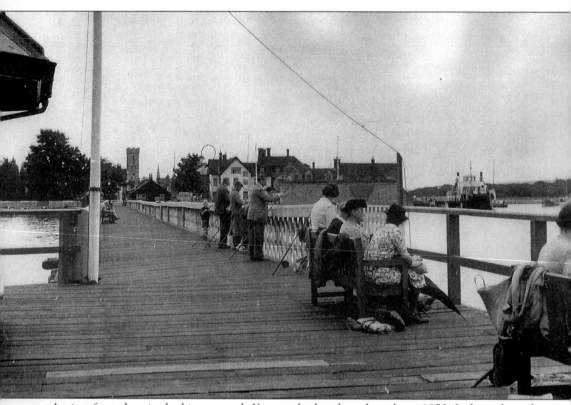

A view from the pier looking towards Yarmouth church and castle, c. 1950. In later days, the pier was given over to fishermen and those who love to sit enjoying the view. A motor ferry now waits at the new slipway to the right of the castle (see page 10).

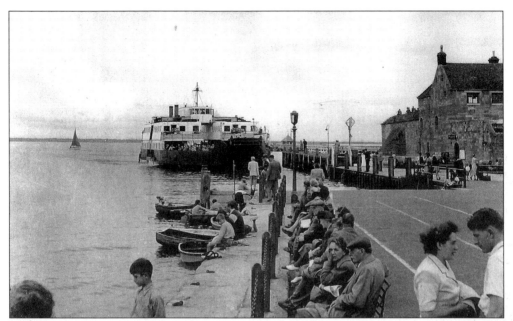

The ferry terminal and castle, *c.* 1950. A motor ferry from Lymington approaches the slipway. Between the wars, cars were transported across the Solent on flat barges drawn by tugs. Normally used for cattle, they had to be cleaned to take cars. In rough weather the barges slewed dangerously, making the crossing very hazardous.

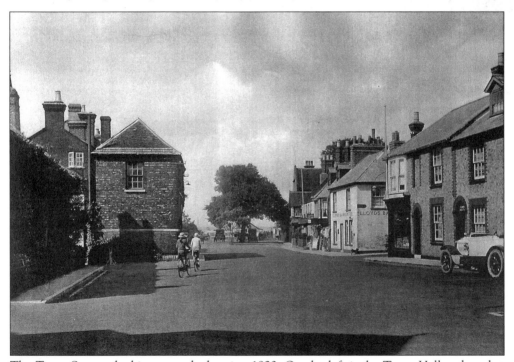

The Town Square, looking towards the pier, 1923. On the left is the Town Hall and market place, built in 1763 by Thomas Lord Holmes (then Governor of the island), the grand-nephew of Sir Robert Holmes (see page 14).

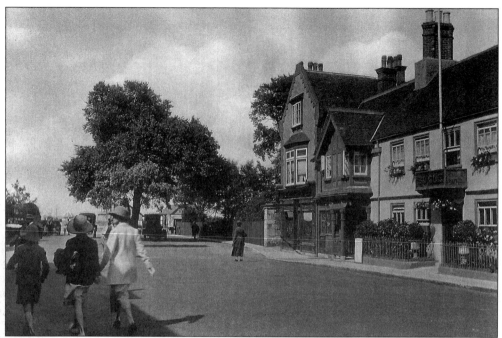

The same view as previously, from a viewpoint closer to the pier. The two cars are still parked by the trees. On the right is the Bugle Hotel, then under the ownership of George Clary. The iron railings in front of it were taken for wartime salvage and replaced by a stone wall (see page 21).

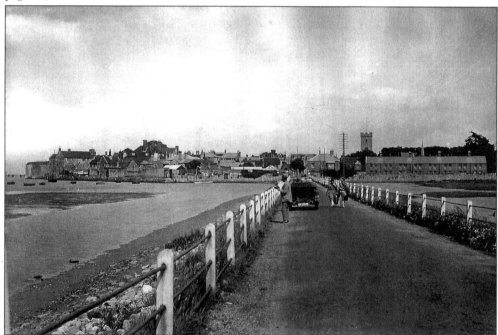

The road from Freshwater to Yarmouth across the Yar River estuary by the causeway and bridge, which were built in 1863. Tolls were levied until 1934. This picture was taken in 1923. The row of buildings to the right was the coastguard's station. Yarmouth Castle is on the far left.

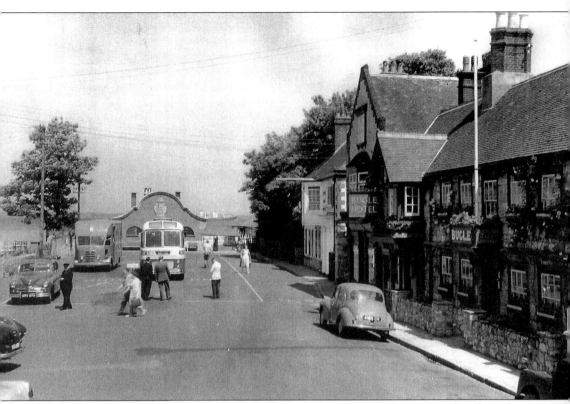

The same scene as at the top of the facing page, in the late 1950s. This picture was taken after the Second World War and during the era of the Morris Minor. A new booking office affords entry to the pier and access to the steamers. Note the stone wall that has replaced the iron railings in front of the Bugle Hotel.

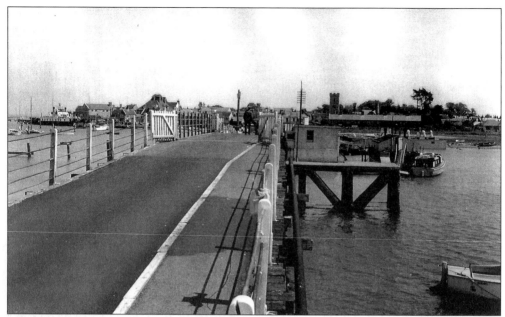

The Yar Bridge in 1950. Motor ferries now use the new slipway adjoining the castle. The coastguard's station is now known as Coastguard Cottages. The area to the left is the harbour and the seabed to the right has been deepened. The bridge has since been replaced by a new million-pound structure designed for modern traffic.

Quay Street, Yarmouth, c. 1950. This photograph gives a glimpse of the harbour with its yacht flotillas. The inn on the right is The George – which was formerly the Pier Hotel.

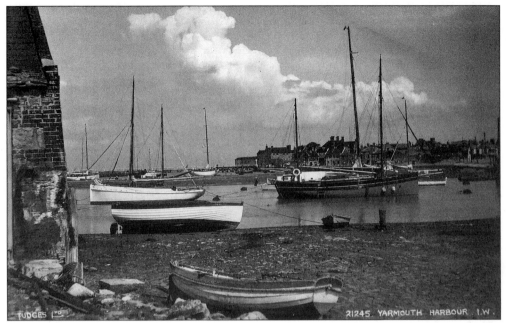

Yarmouth Harbour in 1919. The chimney-stacks of the Pier Hotel are very prominent on the skyline in this picture.

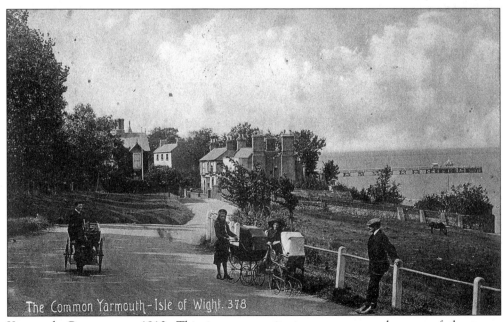

Yarmouth Common, c. 1910. This is an attractive open space to the east of the town, overlooking the Solent with a view of the mainland.

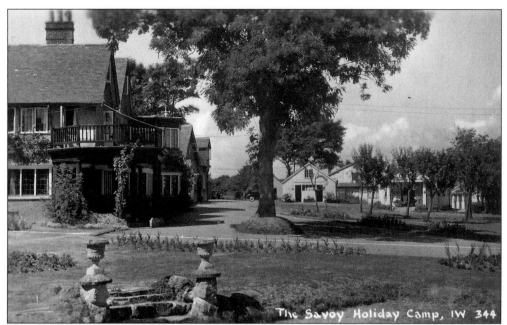

The Savoy Holiday Camp in 1953. This is one of the many enjoyed by holidaymakers in the island throughout the 1950s and 1960s and still is a popular attraction.

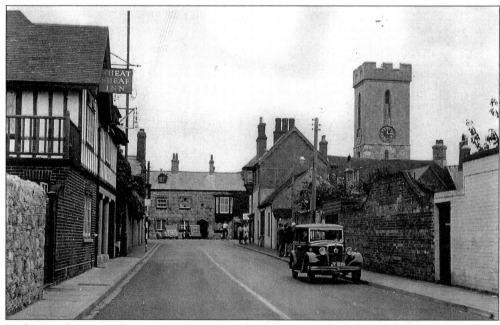

Bridge Road, Yarmouth, c. 1950. The Wheatsheaf Inn is on the left, and St James's church to the right. The road leads into Church Street, opposite Dolphin Cottage.

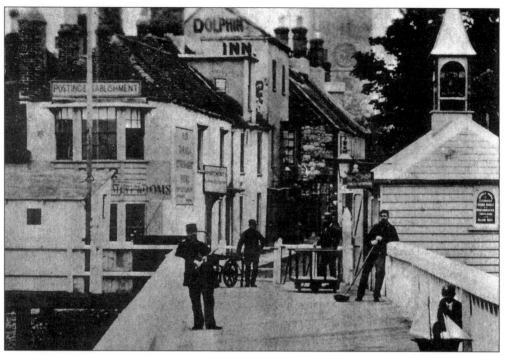

A view from the pier looking landwards, taken in 1890. The buildings to the left have since been demolished and the Dolphin Inn has also gone.

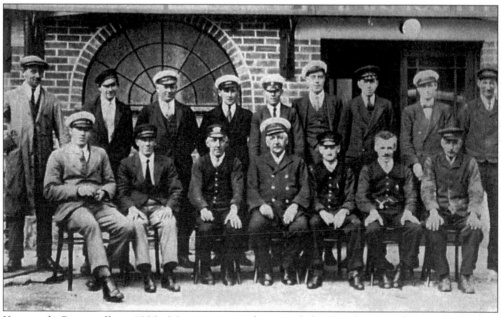

Yarmouth Pier staff, c. 1930. Most were employees of the Southern Railway, which then operated the ferries connecting with the mainland railway terminal at Lymington.

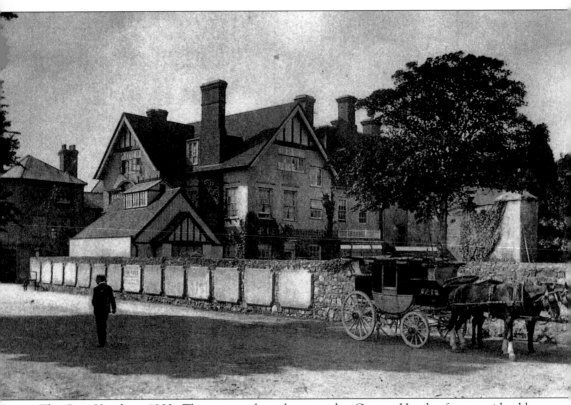

The Pier Hotel, *c*. 1900. This was to later become the George Hotel, after considerable alteration. The Governor of the Isle of Wight used this building as his residence during the seventeenth century. It stands on the right side of the square, looking landwards.

Two
Totland and Alum Bay

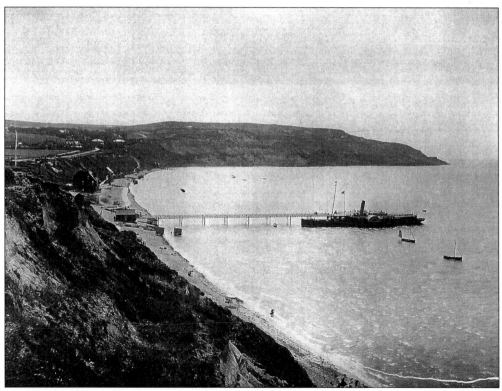

The classic profile of Totland Bay, looking west towards Headon Hill and Hatherwood Point. The name Totland means 'tout-land' or 'the lookout place', and a beacon stood on that point in past times to warn of approaching invasion. This picture was taken in 1912.

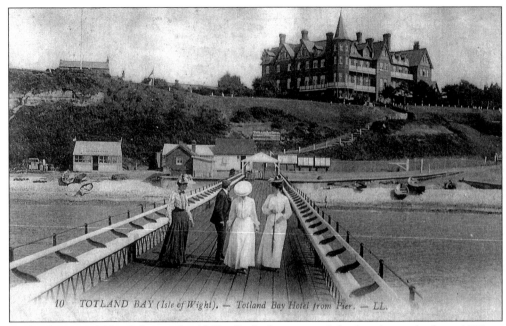

10 TOTLAND BAY (Isle of Wight). — Totland Bay Hotel from Pier. — LL.

Totland Pier and Hotel during the 1880s. Both the pier and the hotel were built in 1880, as Totland became the fashionable resort of West Wight, attracting a distinguished clientele keen to enjoy the ozone and the pure spring waters from the downs.

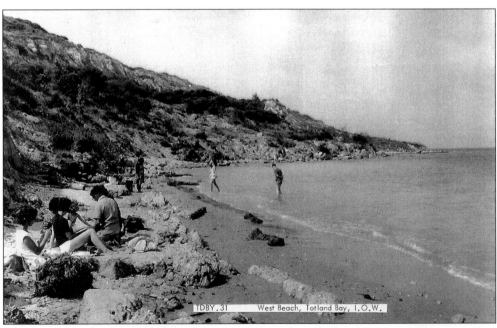

TDBY.31 West Beach, Totland Bay, I.O.W.

West Beach, Totland, c. 1920. This picture provides a closer look at Hatherwood Point. At low tide it is possible to walk around into Alum Bay, if one can negotiate the limestone boulders and treacherous bogs that lie in-between the two of them.

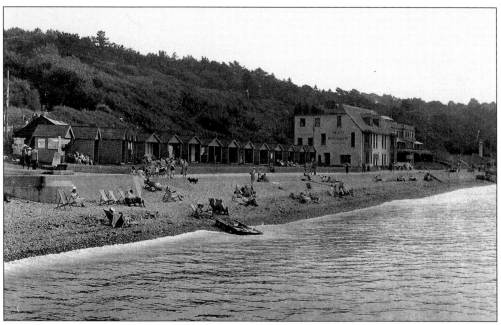

West Beach and cliffs with the Beach Hotel, *c.* 1930. Above is the Turf Walk, or Cliff Walk, leading up to Headon Hill.

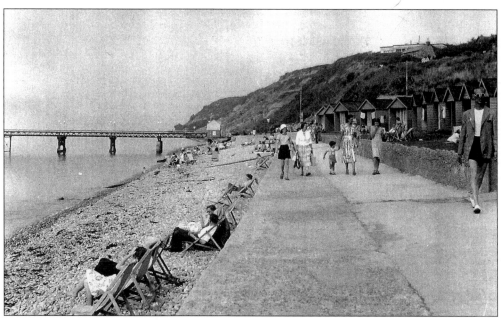

The seafront, Totland, looking east, *c.* 1930. Visitors found this a pleasant way of enjoying the sea view and air and enjoyed many attractions in the form of shops and stalls selling souvenirs and ornaments made from Alum Bay sands.

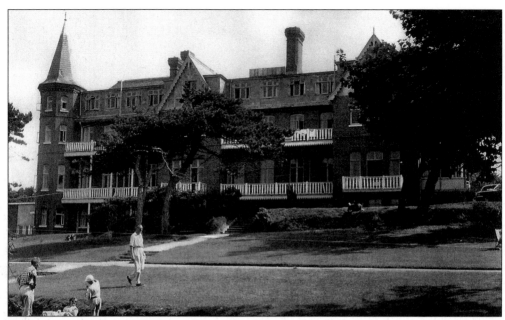

Totland Bay Hotel *c*. 1930. Opened in 1880, this was described as providing the most up-to-date standards of comfort and convenience. The principal owner was Frank Gerard Aman who, during the early 1900s, was a leading proponent of a Solent tunnel that would link Freshwater with the mainland. This scheme was abandoned in 1927 as being financially unjustifiable.

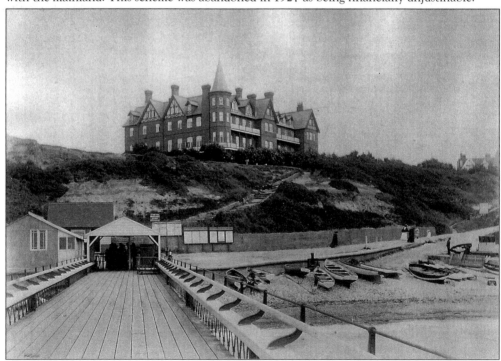

The Totland Bay Hotel commanded a view of the West Beach and the pier. This photograph was taken in around 1920. It was the most prominent feature of the seafront until 1970, when declining patronage led to its closure and demolition.

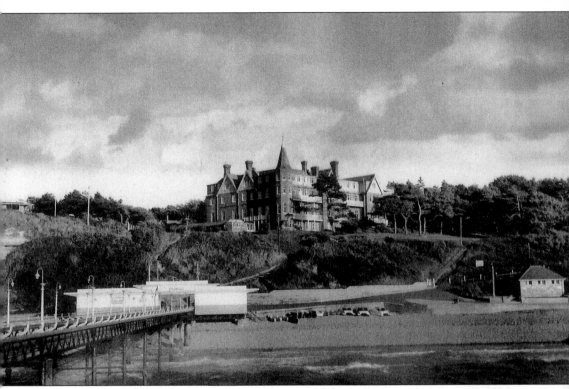

Totland Pier and Hotel again, showing changes to the seafront buildings and pier approaches.

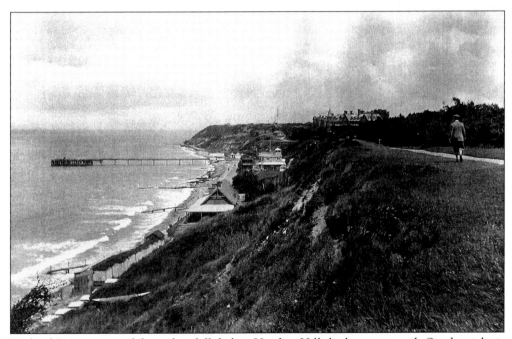

Totland Bay, as viewed from the cliffs below Headon Hill, looking eastward. On the right is Turf Walk.

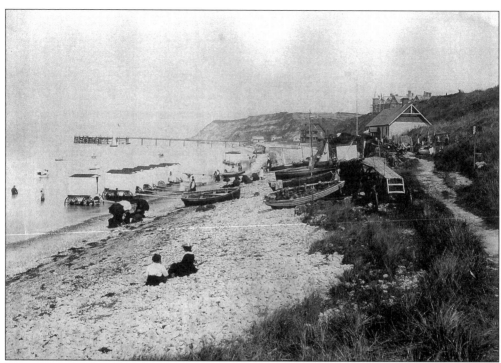

West Beach, Totland, looking eastward, *c.* 1900. From this picture it is clear that boating and bathing were the most popular pastimes at this resort.

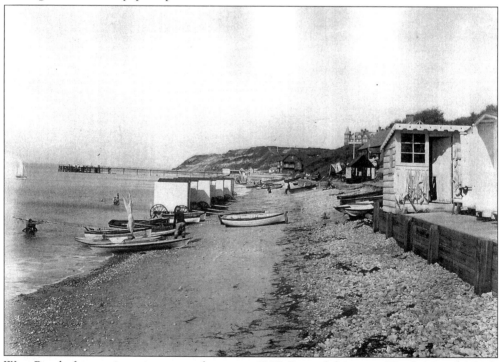

West Beach, from a viewpoint nearer the pier, *c.* 1900. Beyond the pier is Warden Point, which divides Totland from Colwell Bay.

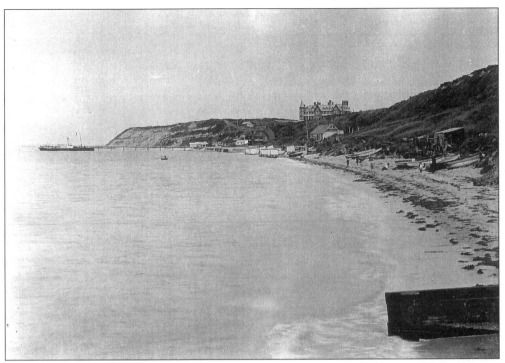

A clearer view of Warden Point, with the hotel and pier in the middle distance. Colwell Bay is beyond the point.

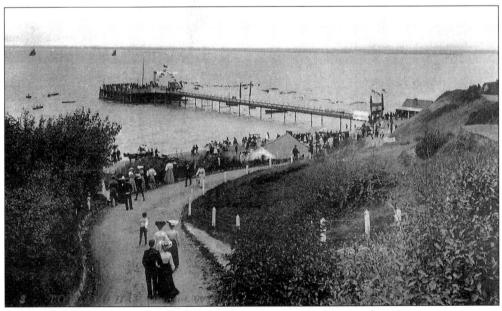

Holidaymakers gathering to embark on an excursion on a steamer, early 1900s.

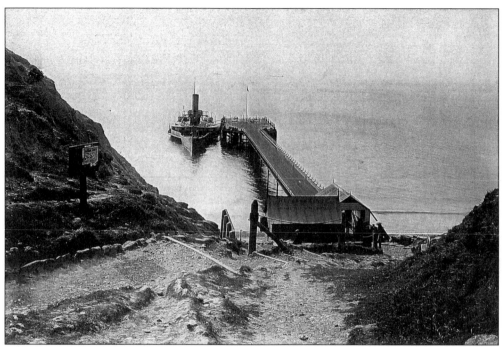

The pier at Alum Bay, *c.* 1912. It was built in around 1863 and used by steamers plying between Yarmouth, Lymington and Bournemouth. Rough seas destroyed it in 1926 and it was never rebuilt.

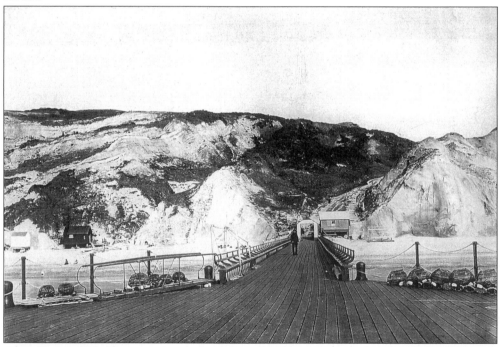

Alum Bay, *c.* 1912. The name comes from the yellow-tinted clay next to the chalk cliffs. From these cliffs Marconi transmitted his first wireless messages in 1897: a monument stands near the spot to commemorate this event.

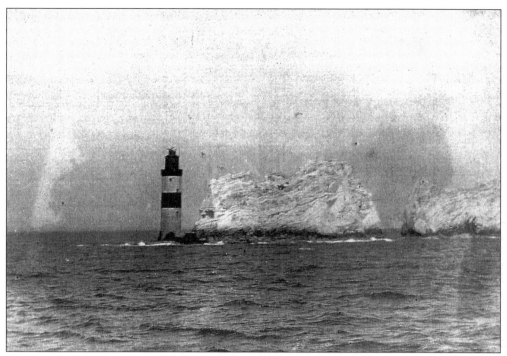

The Needles Lighthouse in 1912. It was built in 1858, replacing an older one that had stood on the cliff-top since 1761. Stone from Portland Bill was used in its construction.

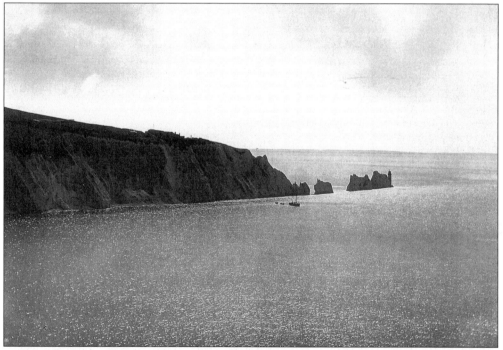

The Needles at sunset, 1912. The gap between the first and second rock mass was formerly occupied by the original 'Needle' – a slender pointed rock about 120 feet high, which fell down one night in 1764. It was also known as 'Lot's Wife'.

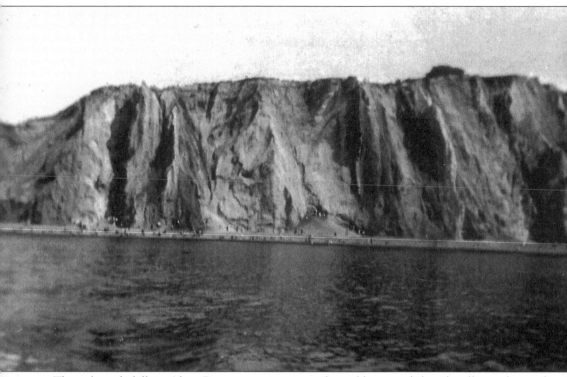

The coloured cliffs in Alum Bay are varying tints of grey-blue, purplish-red, yellow ochre and black. They are the result of a geological upheaval several million years ago, which forced a section of the horizontal strata into a vertical position.

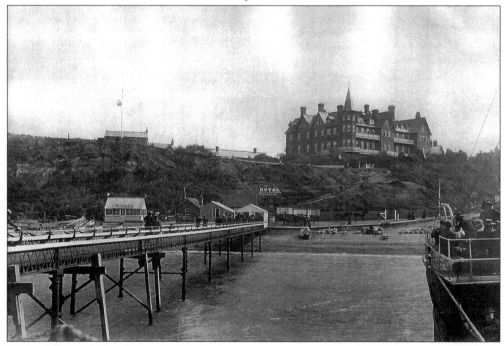

Totland Pier and Hotel, from the deck of a steamer.

Three

The History Makers

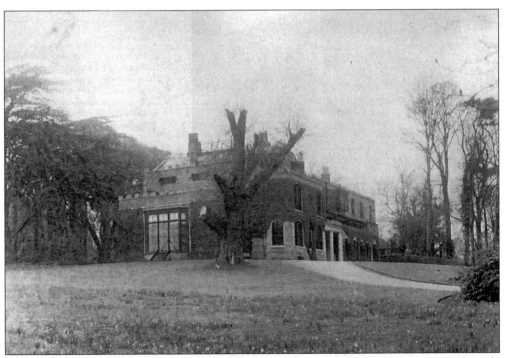

Farringford, the home of Alfred Lord Tennyson. In the thirteenth century, Walter de Faringford, the prior of Domus Dei in Portsmouth, leased the land in Freshwater, upon which this house was subsequently built in 1806. The picture is the view from the front.

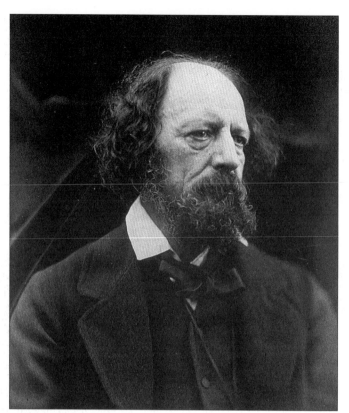

Alfred Lord Tennyson (1809-1892) was born in Somersby, Lincolnshire, the fourth son in a family of twelve. In 1850 he married Emily Sellwood, the daughter of a solicitor and, in the same year, was appointed Poet Laureate. They moved to Farringford three years later, purchasing it in 1856 with monies earned by the publication of his poem *In Memoriam*. There were two sons by their marriage, Hallam and Lionel; sadly, Lionel died in his twenty-fifth year, on a voyage home from India.

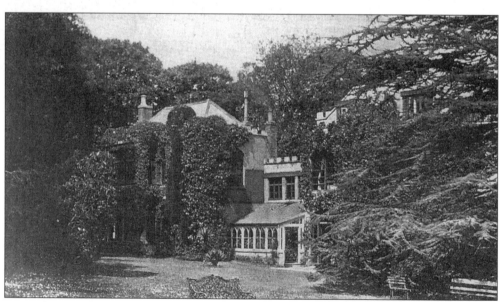

Farringford House, rear view. Alfred and Emily Tennyson took the house on a short lease on coming to Freshwater in 1853 and were so enchanted with the surroundings that they decided to make it their permanent residence.

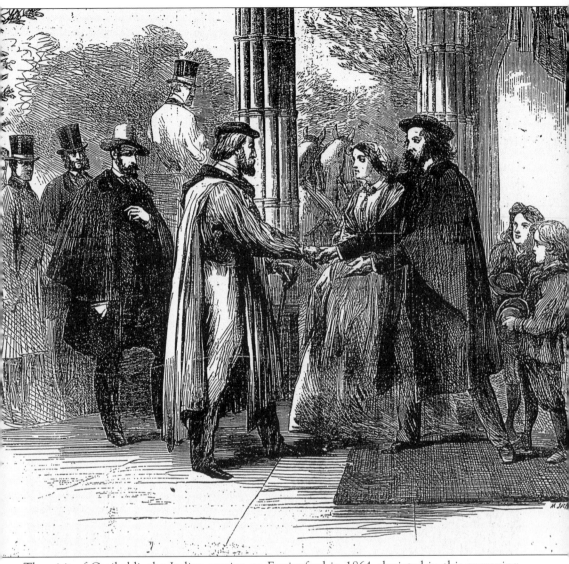

The visit of Garibaldi, the Italian patriot, to Farringford in 1864, depicted in this engraving from the *Illustrated London News*. Tennyson, who possessed a world-wide outlook, was very interested in the implications of Italian unification.

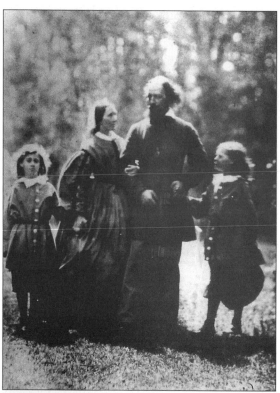

Alfred and Emily Tennyson, with their children Hallam and Lionel, in their garden at Farringford, 1862. This photograph was taken by O.G. Rijlander.

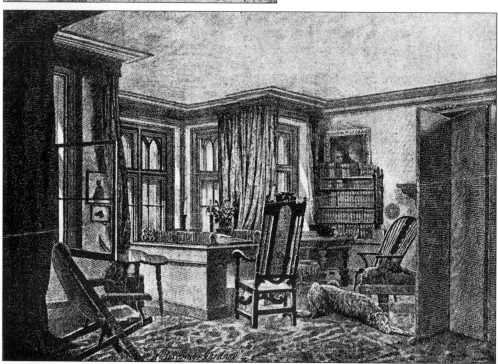

Tennyson's study at Farringford, as drawn by W. Biscombe Gardener. It shows his favourite deerhound, Lufra, in the foreground.

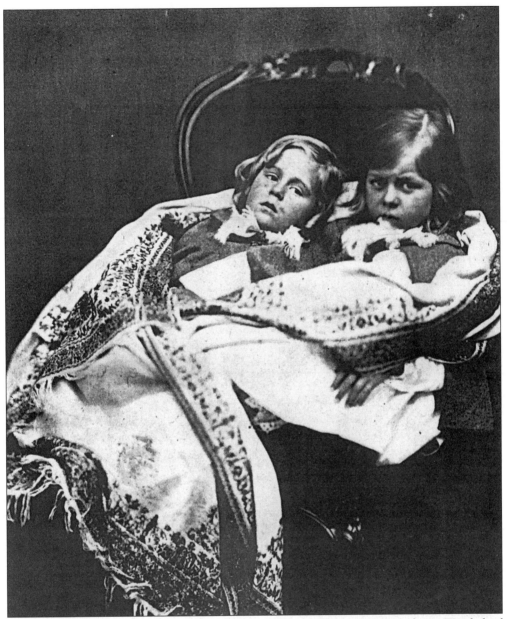

Hallam and Lionel Tennyson as children, photographed by Lewis Carrol, of *Alice in Wonderland* and *Through the Looking Glass* fame.

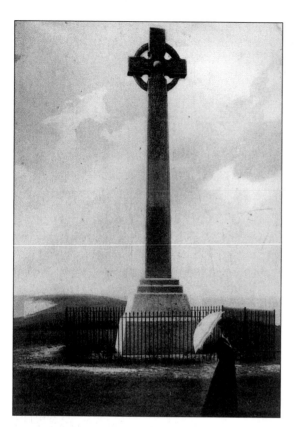

Tennyson's Memorial Cross (or Monument), taken soon after its dedication. It is thirty-eight feet high and made from Cornish granite, according to the wishes of Hallam, the poet's son. It was unveiled on 6 August 1897 by the Dean of Westminster.

Weston Manor, from the architect's print, *c.* 1879.

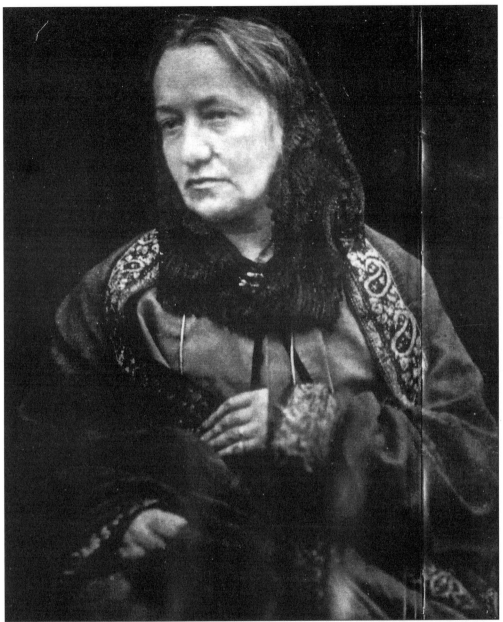

Julia Margaret Cameron (1815-1879), the pioneering woman photographer and friend and neighbour to the Tennysons. She took up photography to occupy her time during her husband's frequent absences abroad. The result was a priceless heritage of immortal studies of famous visitors to Freshwater, as well as of local everyday folk.

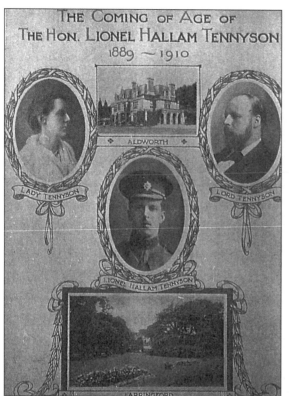

THE COMING OF AGE OF
THE HON. LIONEL HALLAM TENNYSON
1889 ~ 1910

ALDWORTH

LADY TENNYSON

LORD TENNYSON

LIONEL HALLAM TENNYSON

FARRINGFORD

A special postcard celebrating the coming of age of Lionel Hallam Tennyson, son of Hallam and the grandson of the Poet Laureate. He later became a leading cricketer and captained England. The Lady Tennyson was Audrey Boyle, who modelled the angel in the picture on page 121. The upper picture of the group shows Aldworth, the Sussex summer home of Alfred Tennyson.

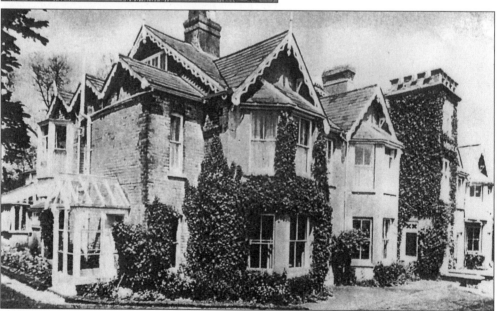

Dimbola was the home of Julia Cameron. The house was named after a coffee plantation in Ceylon (now Sri Lanka), owned by her husband. They bought the house in 1860, and lived there until 1875, when they returned to Ceylon. It later became a hotel and holiday accommodation, but more recently it was restored as a museum for Cameron memorabilia and a centre for study.

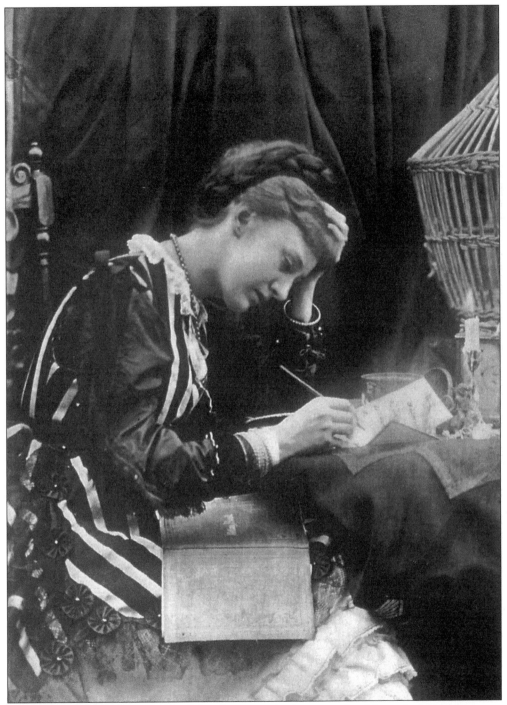

May Prinsep, as photographed by Julia Cameron, in the pose of writing a letter. May was an adopted niece of Mrs Cameron. She became the second wife of Hallam Tennyson, the poet's elder son, after the death of his first wife in 1915. May was mistress of Farringford until around 1934 and was noted for her local benefactions, including a Sunday school for local children and the endowment of the Tennyson ambulance.

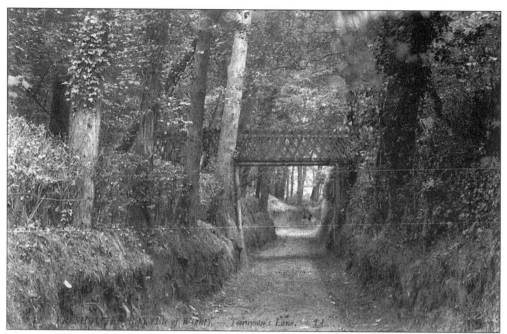

The rustic footbridge spanning Tennyson's Lane, leading from Gate Lane to Farringford Farm. It was constructed to allow Tennyson direct access to his favourite walks on the downs, free from the attentions of sightseers and tourists, whom he detested. This picture dates from 1910.

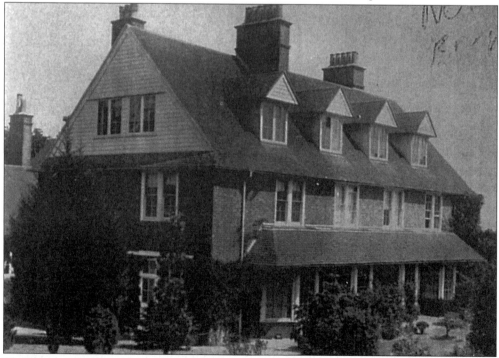

The Briary, Middleton. It was built by the painter George Frederick Watts, to the design of Philip Webb, for his friends, the Prinseps. It was a centre of much artistic activity and Watts painted many of his landscapes studies of the island here. It was burnt down in 1934.

William George Ward (1812-1882), the original 'Squire' of Weston and a great friend of Tennyson. He lived at Weston Manor from 1879 until 1882, when his son Edmund Granville inherited the estate.

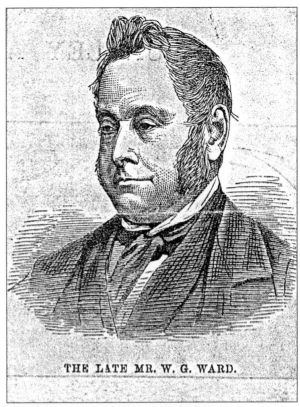

THE LATE MR. W. G. WARD.

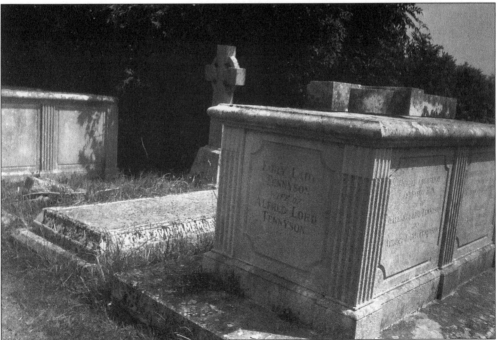

The tomb of Lady Tennyson in the churchyard of All Saints. Nearby are the resting-places of other members of her family.

The Conway family of Freshwater, basking on the cliffs above Totland Bay. The Conways were the owners of the shore amenities of neighbouring Colwell Bay.

A carved stone built into the wall of Greystones, a cottage in Camp Road. It depicts the 'Lamb and Star', or 'Agnus Dei'. It is believed to be the arms of Catherine of Braganza, the wife of Charles II. It is not known what connection this queen had with Greystones, or its occupants.

Cameron House, adjoining Dimbola (Julia Cameron's residence). It is now part of the complex that houses Cameron memorabilia.

This carved stone, also built into the wall of Greystones, bears a heraldic leopard's head. This cottage, or at least its foundations, is believed to be 300 or 400 years old.

The Hawkridge, built on the site of Hawkridge Farm for Agnes Grace Weld, a niece of Emily Tennyson, the wife of the Poet Laureate. It was said to be much used by smugglers for the storage of illicit spirits, apparently unknown to Agnes.

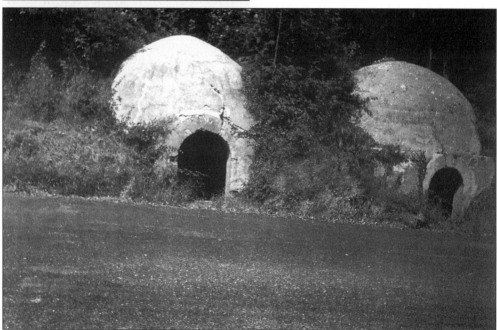

These curious structures are on the north side of Moons Hill, near Weston Manor. Numerous explanations exist of their origin and purpose, but the consensus appears to be that they are Romano-British pottery kilns.

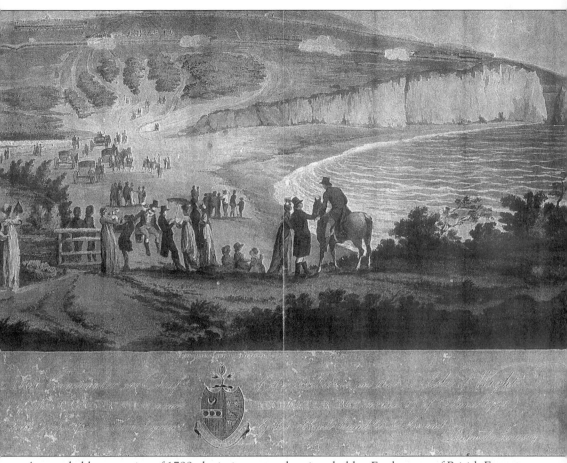

A remarkable engraving of 1799, depicting a grand review, held at Freshwater, of British Forces, doubtless stationed on the island to meet the threat of invasion by Napoleon.

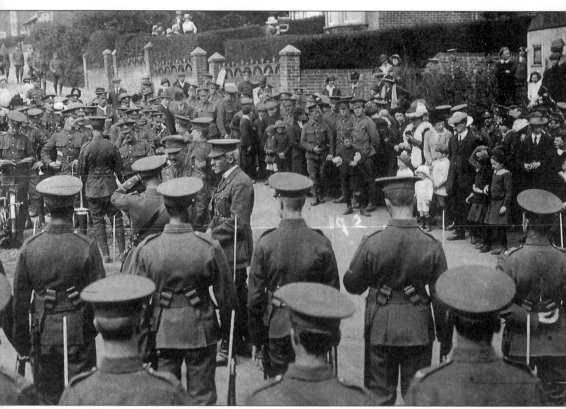

A guard of honour formed for Princess Beatrice of Battenburg, who was Governor of the Isle of Wight, in around 1914. A few years later, during the First World War, the House of Battenburg changed its name to Mountbatten for patriotic reasons.

George Frederick Watts (1817-1904), the gifted Victorian painter. He built the Briary for his friends the Prinseps and lived there himself for a while. He became a great friend of Tennyson and of Julia Cameron, who photographed him here when he had laid aside his palette and brushes for a while to entertain one of his young friends on the violin.

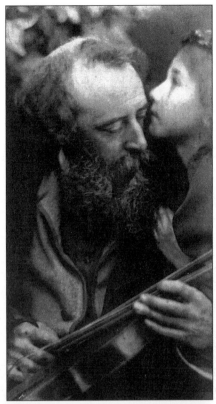

The memorial stone to Robert Hooke, son of John Hooke the one-time curate of Freshwater during the early-seventeenth century. He was renowned for his scientific discoveries and researches, which rivalled those of Isaac Newton in the following century. The stone was unveiled by Earl Mountbatten in 1966.

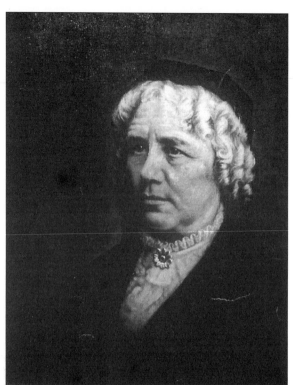

Maria Mitchell was born in 1819 in Nantucket, USA, to a family of Quakers. Being part of a whaling community, study of stars was essential for the navigation of their vessels and she gained a deep knowledge of astronomy while assisting in their investigations. She died in 1889.

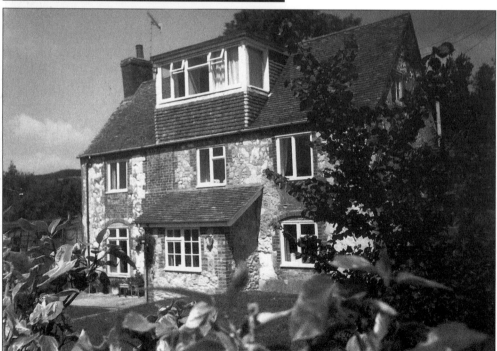

Mitchell's Cottage, Brighstone. This was the birthplace of Richard Mitchell in 1686. He emigrated to Rhode Island, USA, in 1708. He was the great-great-grandfather of Maria Mitchell, the first woman astronomer in America.

Four
Traders and Toilers

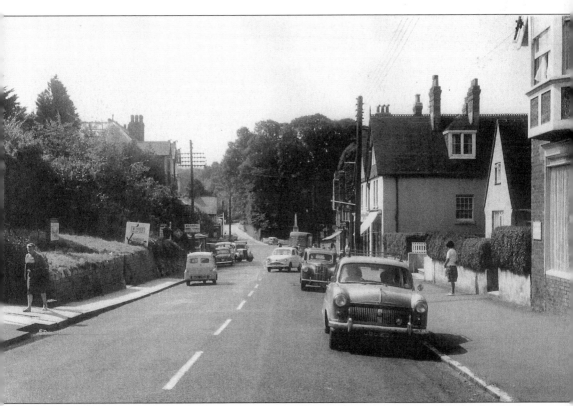

Totland Broadway, looking south-west, c. 1960. This is the main street of Totland, which became a separate parish in 1894 as the seaside resort grew in popularity. The right fork at the foot of the hill leads to Alum Bay.

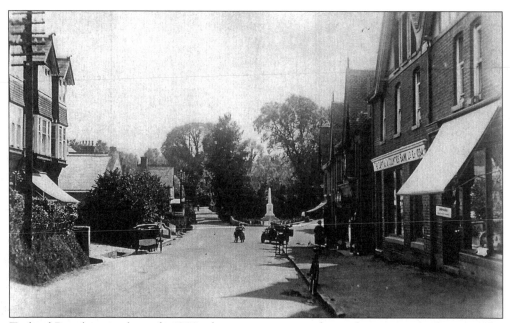

Totland Broadway in the early 1920s, from a point nearer the road junction. At this time, the war memorial is conspicuous in its newness.

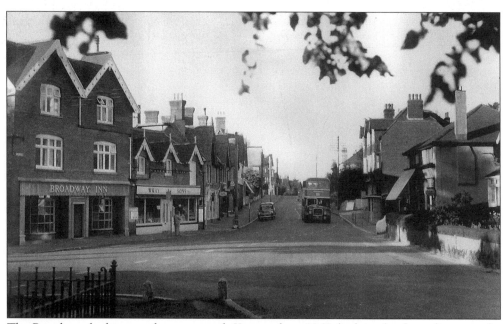

The Broadway, looking north-east towards Yarmouth, *c.* 1960 (judging by the radiator on the diesel bus). The viewpoint is from the base of the war memorial.

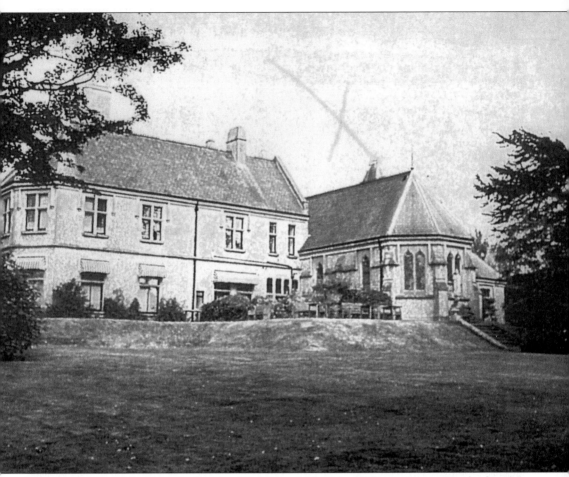

Weston Manor was built to the design of Goldie and Child by William George Ward, when he had to resign Holy Orders upon his convertion to Catholicism. He was a neighbour and close friend to Alfred Tennyson, in spite of marked differences in theological outlook. For many years, Sunday mass was celebrated in the chapel, serving worshippers in the surrounding districts.

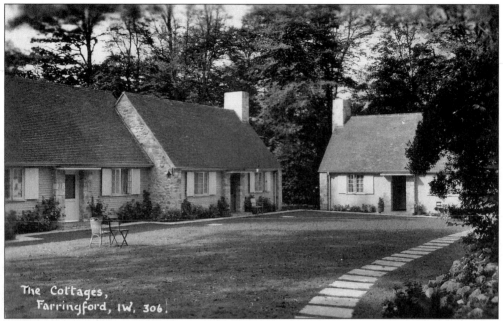

Farringford Cottages, *c.* 1950. This was built on the estate, for tenants and workers of the Farringford estate and farms.

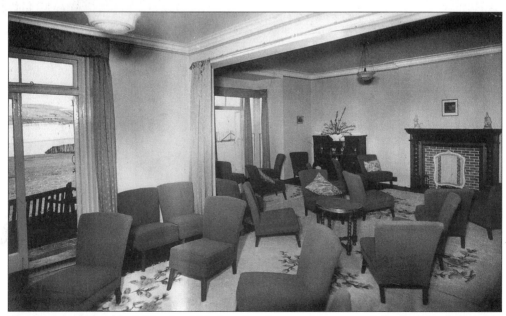

The lounge of Plumbley's Hotel, which is today the common room of the Holiday Fellowship Centre. Through the window on the left can be glimpsed the Isle of Wight coastline.

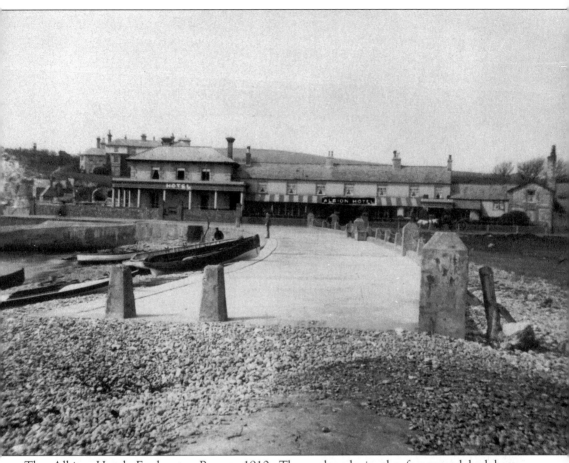

The Albion Hotel, Freshwater Bay, c. 1910. The esplanade in the foreground had been destroyed in heavy seas by 1920.

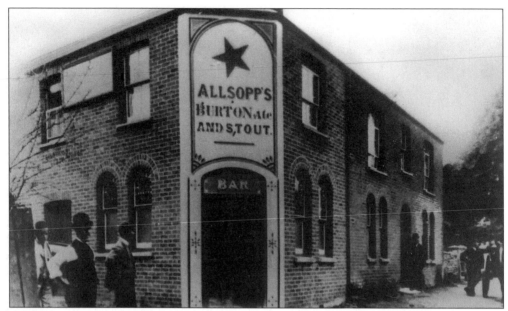

The Star Inn was originally a private house at the corner of Camp Road and New Village. It became a popular public house for the local workpeople, employed to meet the building demands of visitors and newcomers attracted by the growing fame of Freshwater. It is now a private house once more.

Sheepwash Farm, *c.* 1850. It is situated in Middleton, about a mile away from the bay. The farm was purchased by Jeremiah Merwood, a former coachman to Lord Tennyson. He was brother to Harriet Merwood, who married William Mitchell, great-grandfather to one of the authors of this book. One of his daughters married Charles Osman, and the property has been held by the Osmans ever since.

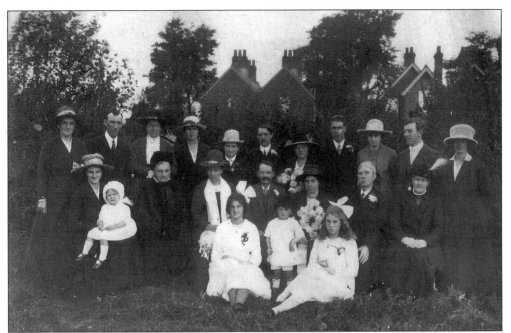

A Freshwater family wedding group photograph, taken during the late 1920s (although the married couple are rather difficult to identify). Seated in the front row, second from the left, is Ann Mitchell, a life-long resident of Freshwater till she died in 1933, aged ninety-one. She was the grandmother of the married couple, and several other of her descendants are also in the group.

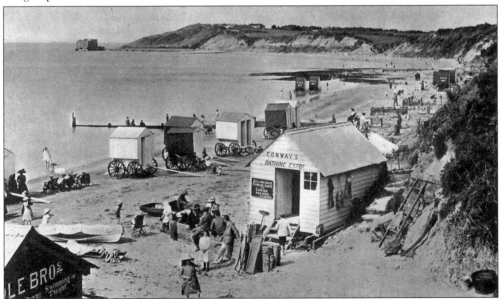

Colwell Bay, c. 1900. This bay adjoins Totland Bay, facing north-west across the Solent. It is the favourite family resort of West Wight, with its sandy beaches and safe bathing, catered for with amenities provided by the Conway brothers and their friendly rivals, the Coles. To the far left is Fort Albert, which guarded Warden Point. It was built by Palmerston in 1857 and is now holiday flats.

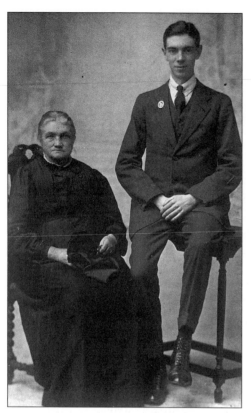

Mrs Ann Mitchell, *c.* 1914. She is sitting with Arthur, one of her grandsons. Not long after this picture was taken, Arthur died while serving in the First World War. At her death in 1933, Mrs Mitchell had had thirteen children (seven surviving), forty-nine grandchildren, eighty-four great-grandchildren, and one great-great-grandchild – a total of 147 descendants.

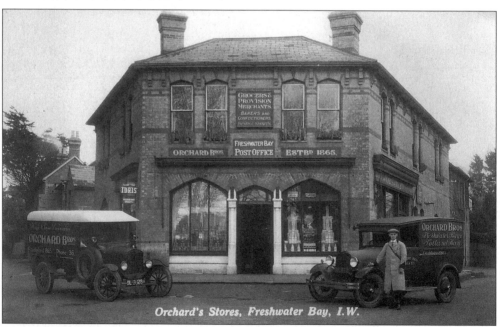

Orchard's Stores, Freshwater Bay, I.W.

Orchard's Stores in 1920. The building dates from 1845. The Orchards were originally coal merchants, who took over the house as a store for the sale of general provisions in 1865. It was once the scene of a meeting between Tennyson and the American poet Longfellow.

This photograph, taken around 1900, is of Emma, one of the daughters of Ann Mitchell, with three of her own daughters.

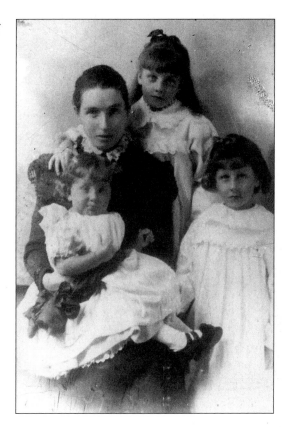

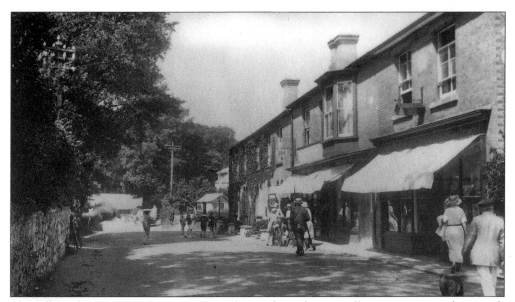

The village shops in Gate Lane, c. 1923. This is where the post office is now situated: it stands in a shop which was formerly the premises of the Queen's piano tuner, who had charge of the pianos in Osborne House.

The Military Road, starting at Freshwater Bay, follows the southern coast of the island towards Blackgang and crosses Grange Chine, half-a-mile from Brighstone, over this handsome viaduct.

The main street of Freshwater village, named School Green, after the National School nearby. Its original name was Doves Lane, but it later became Station Road when the railway was in operation.

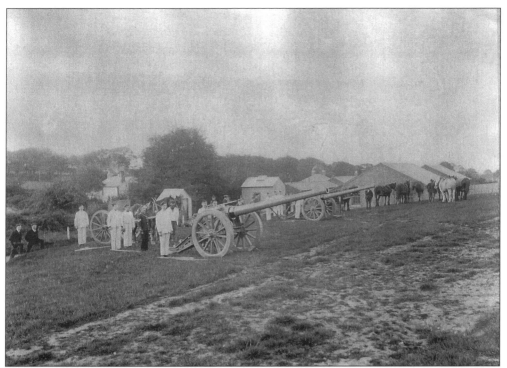

Gunnery practise at Golden Hill, probably sometime between the wars. This is obviously a detachment of the Horse Artillery, manning the strategic defence points of the island.

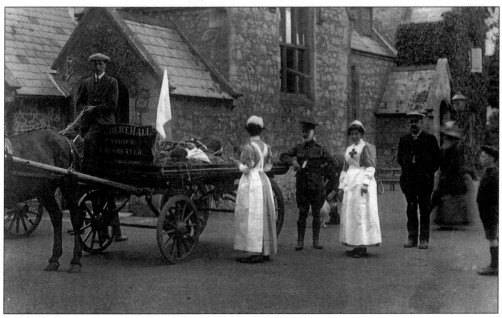

A first aid exercise carried out by Red Cross personnel outside All Saints' School during the First World War. Note the 'casualty' being conveyed on the cart requisitioned from Mr Hall.

A cottage at the Causeway, Freshwater. The dog is evidently resigned to waiting until his master has finished his conversation. To judge from the gentlemen's costumes, the date is probably pre-1914.

Tom Reason, Freshwater's own cabby, waits while his horse receives attention at the smithy near Moa Place in 1925. Tom was also a supplier of dairy produce.

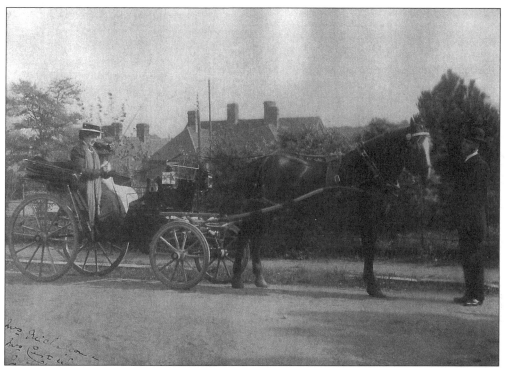

Mrs Nicholson and her companion are about to set out on a drive to Alum Bay in their carriage, drawn by their horse, Sunny. This photograph was taken in 1908

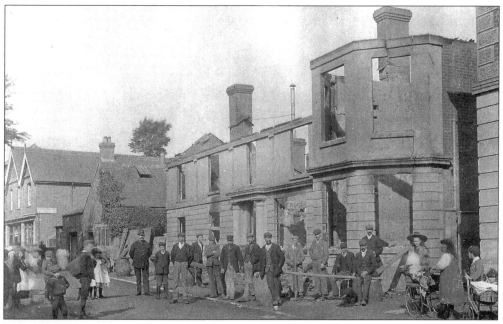

The old Royal Standard, School Green, after its destruction by fire in 1905.

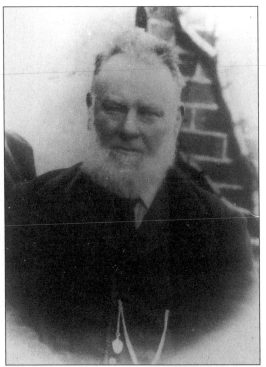

Joseph Mitchell (1839-1915), a sturdy yeoman and one of the team employed on the building of St Agnes' church, Freshwater, and many other building developments in the locality.

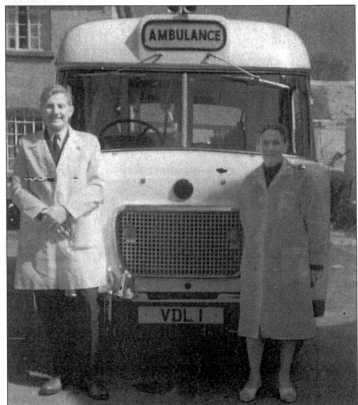

The Tennyson Memorial Ambulance, with two of its dedicated drivers. It is the fifth in succession to the original ambulance, presented by May, Lady Tennyson.

Ann Mitchell, *née* Whitewood (1843-1933), was a laundress and staunch mother of thirteen sons and daughters, all of whom lived till adulthood. She and Joseph lived at New Village.

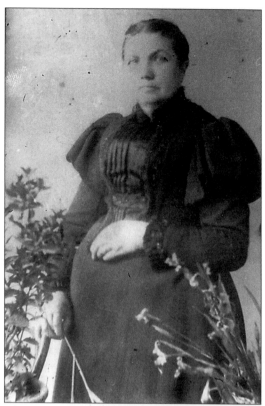

Wayte's Court, Brighstone. Believed to be the court house of the old manor and the home of the Waites family, who were amongst the largest landowners in the district.

Stonewinds Farm between Middleton and Totland. The name suggests a bleak and exposed homestead, but in fact it lies in a hollow. It was built with stones from a nearby windmill, hence its curious name.

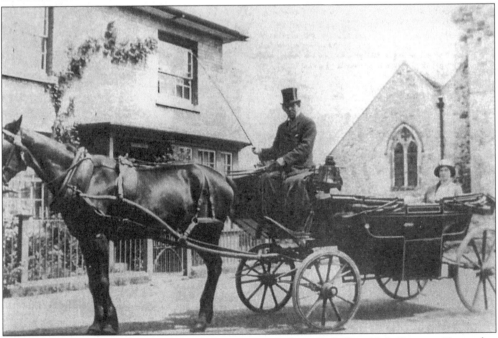

The cabdriver is a well-known local figure, popularly called 'Bumble' Groves. He and a passenger are waiting outside the Red Lion. In the background, can be seen part of All Saints church. It can be assumed that the lady has just attended the latter of the two places!

Recluse Lodge, in Bay Road off Gate Lane, was built in 1881 as a home for the impoverished elderly. It still functions successfully as a residential care home, under the name 'Ancona'.

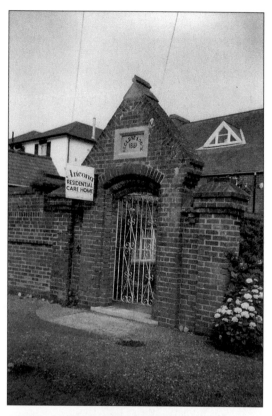

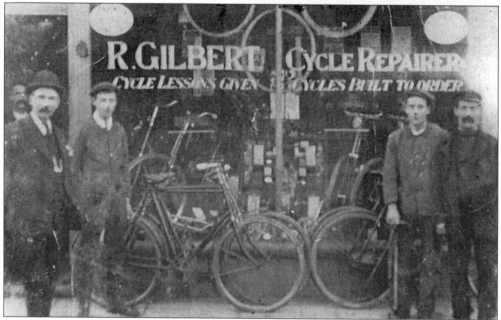

The cycle shop owned by R. Gilbert, cycle repairer. The mother of the family, Mary Gilbert, was formerly Mary Hillier – one of Julia Cameron's maidservants and a model for many of her photographic studies.

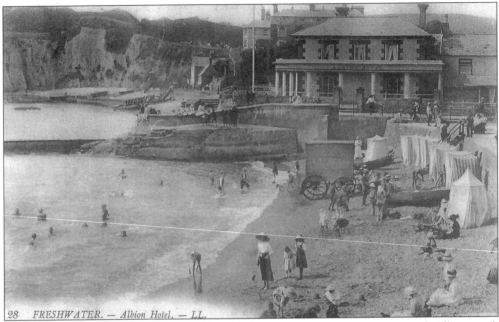

28 FRESHWATER. — Albion Hotel. — LL.

The Albion Hotel, Freshwater Bay, c. 1906. It was formerly called The Royal Albion and, before that, simply The Cabin. It had been a favourite haunt of the painter George Morland.

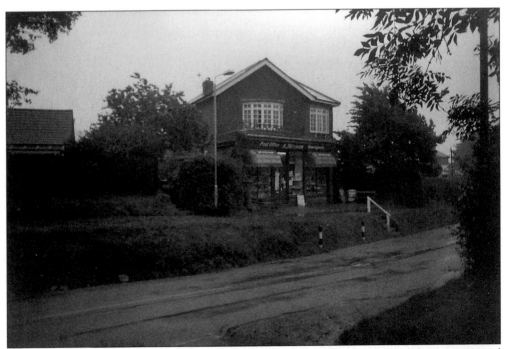

The post office, Gate Lane. It was originally owned by a Mr Gubbin, who hired out pianos and undertook the upkeep of the pianos at Osborne House. Later, it was taken over by two cousins, the Misses Woolf and Geer, who ran the business very successfully for many years.

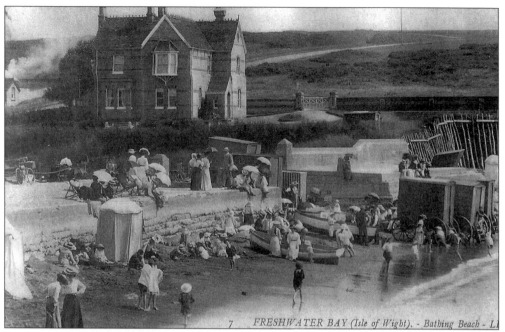

7 FRESHWATER BAY (Isle of Wight). - Bathing Beach - L

A view of the eastern end of the bathing beach in Freshwater Bay, *c*. 1906. Long gowns, hats and sunshades appear not to inhibit enjoyment of the pleasures of the seaside.

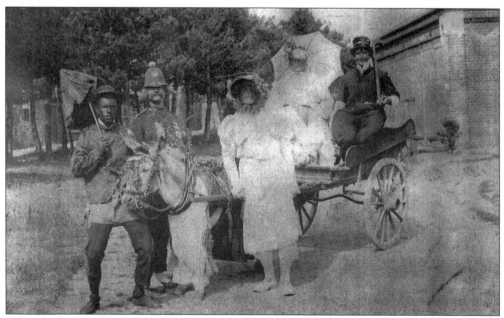

'Our Connie' in a costume party for a carnival and sports day in Freshwater in 1906.

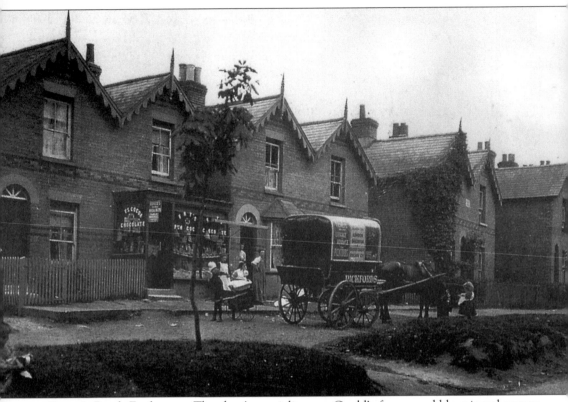

Queen's Road, Freshwater. The shop's speciality was Gould's famous pebble mineral waters. The date of the picture appears to be around 1914, as Pickford's transport became motorised after that date.

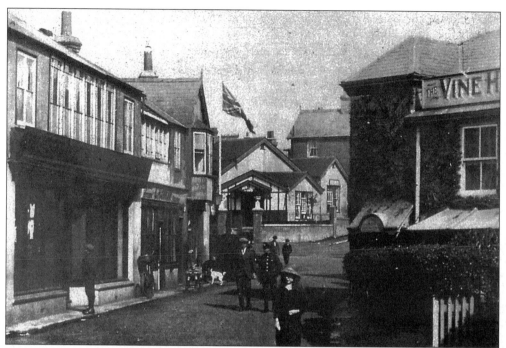

The Freshwater Soldiers' Club, flying the union flag, can be seen in this picture of the Vine Hotel Corner in 1920. The shops on the left side of the street included Hannam's the butcher and Lithgow's bakery.

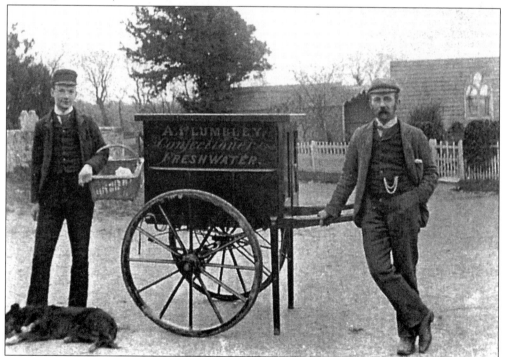

Plumbley's handcraft. The Plumbleys were a noted trading family of the district, owning land at Middleton as well as being owners of the former Lambert's Hotel at Freshwater Bay.

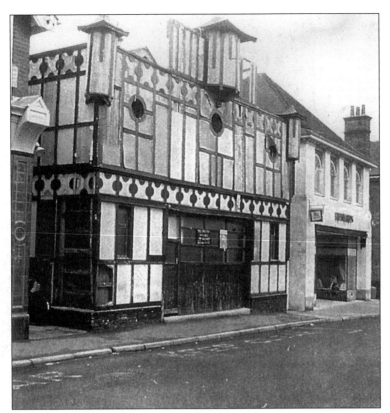

The old cinema in School Green Road, having at last closed its doors after years of providing drama and romance to the local townsfolk. After 1954 it was used as a wire-work factory, until it was finally demolished in 1969.

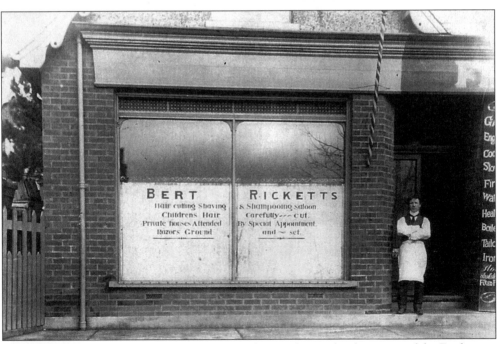

The barber shop of Bert Ricketts in Avenue Road. Next door is the showroom of the Freshwater Gas Company. Today, the shop has become the local office of Francis Pitts, the estate agent.

Norton Green, Freshwater's northernmost hamlet, as its name suggests. Somewhat separate from the rest of the community, it has its own unique character and atmosphere. On the far left is the former village chapel and institute which has today become a private residence.

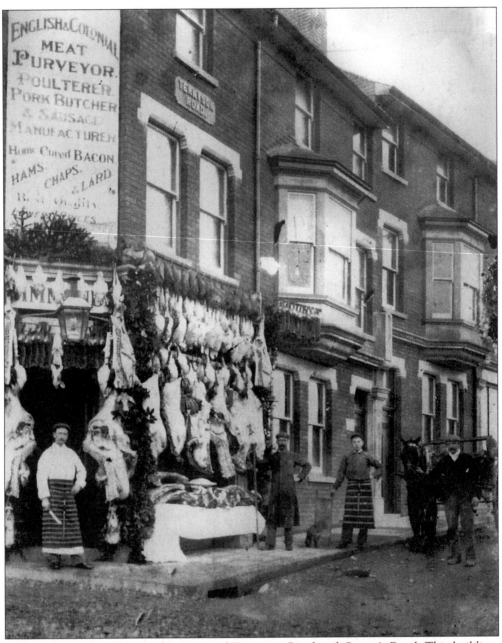

Simmonds' butchers shop at the corner of Tennyson Road and Queen's Road. This building, known as 'Tennyson Building', has since been occupied by a branch of Lloyds Bank.

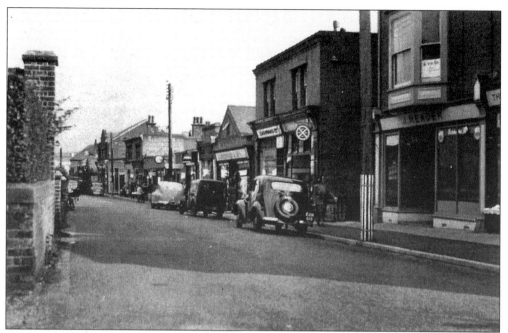

Avenue Road, Freshwater, in the 1950s. This picture gives us a fair impression of the village scene on a working day. 'Macfisheries' logo can be easily picked out.

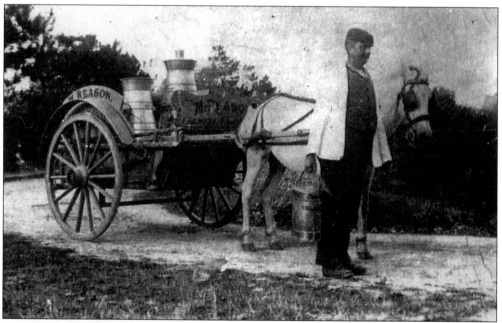

Tom Reason's milk float. Before the days of bottled, pasteurised milk and mobile floats, milk came direct from the farm at 3d a pint. Mr Reason was an active member of the Colwell Baptist church. He also owned the local cab.

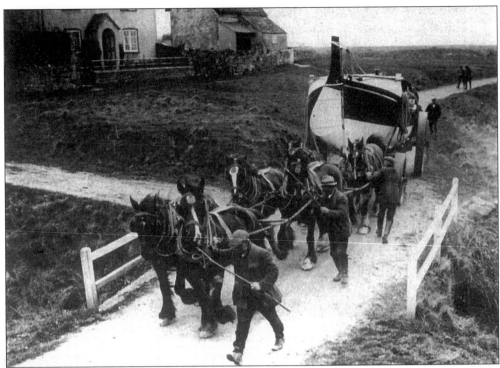

Six horses drawing the Brook lifeboat during an exercise in the 1920s. The lifeboat men of Brook and Brighstone can be proud of their record of lives saved from the many wrecks occurring along the dangerous shores of the island between 1860 and 1936.

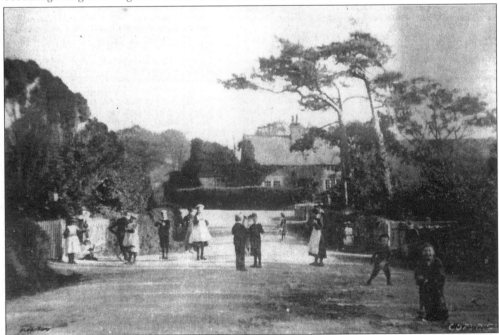

Children of Hulverstone, near Brook, playing by their school. This was built by Sir Charles Seely MP (later Lord Mottistone), in 1872.

Five
Land and Sea

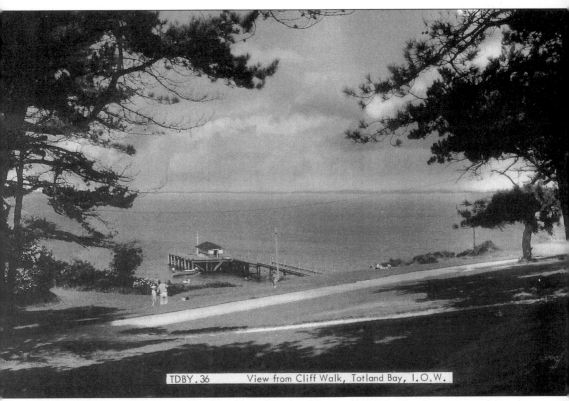

TDBY.36 View from Cliff Walk, Totland Bay, I.O.W.

The Turf Walk (or Cliff Walk) with a view of Totland Pier, *c.* 1930. In the distance can be seen the mainland, on the other side of the Solent.

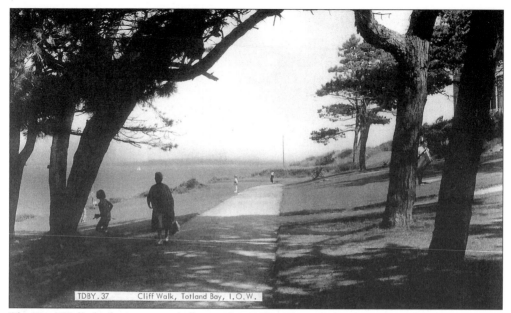

The Turf Walk, looking eastwards during the 1930s. The mainland can again be seen in the far distance.

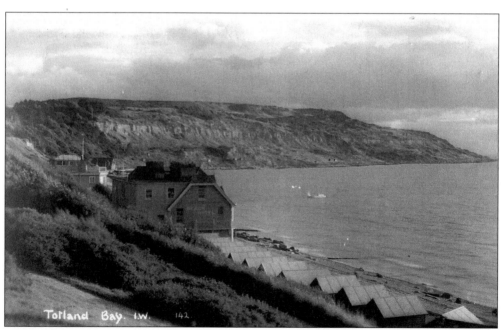

Headon hill and Hatherwood point, Totland, showing the Beach Hotel in the foreground. Just beyond the hotel is the Totland lifeboat station. The sheltered nature of the bay made it ideal for boating and bathing.

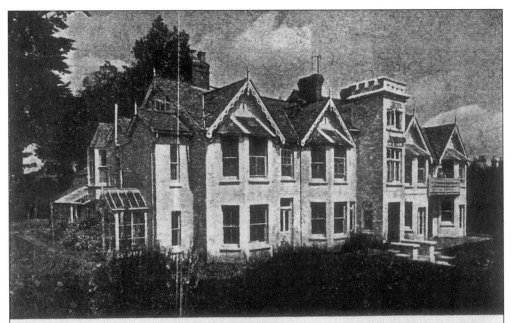

DIMBOLA, FRESHWATER BAY, I.O.W.

DIMBOLA

FRESHWATER BAY
ISLE OF WIGHT

Telephone and Telegrams :
FRESHWATER 421 ; GUESTS 493

DIMBOLA, once the home of Julia Margaret Cameron of photographic fame, has many literary associations.

Now a hotel, it stands in grounds in a fine position overlooking sea and downs.

The proprietors will be pleased to forward illustrated brochure on request.

A page from a brochure advertising Dimbola in its post-Cameron era, when it catered most excellently as a guesthouse for discerning holidaymakers.

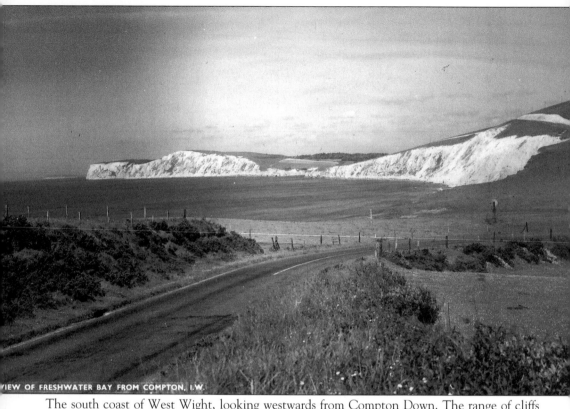

VIEW OF FRESHWATER BAY FROM COMPTON, I.W.

The south coast of West Wight, looking westwards from Compton Down. The range of cliffs terminating with the Needles (not visible here) are seen to advantage, with Freshwater Bay located where the chalk range dips.

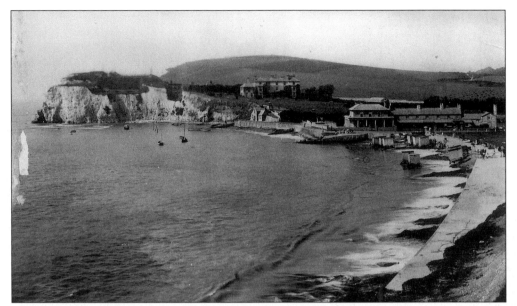

Freshwater Bay in 1890. On the left is the Redoubt, one of Palmerston's forts. Right of centre is the Royal Albion Hotel (formerly called The Cabin) and above it is Plumbley's Hotel, since called the Freshwater Bay Hotel and, now, the Holiday Fellowship Centre.

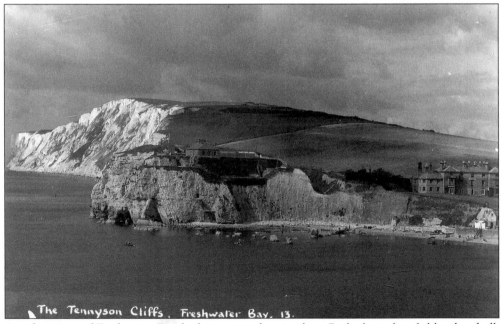

Another view of Freshwater Bay looking west, showing how Redoubt is dwarfed by the chalk cliffs of Tennyson Down beyond. The caves at the foot of the Redoubt had to be reinforced to resist the weight of the fortifications above.

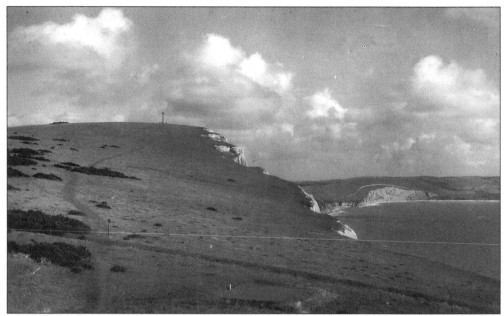

Tennyson Down (also called High Down), looking eastward from the Needles golf links. It was here that, in 1910, the first aeroplane landing took place in the Isle of Wight. The machine was piloted by Robert Loraine, who had been caught in a heavy rainstorm and lost his way. Soldiers afterwards pushed his machine, a Henry Farman biplane, into a position from which he could take-off to continue his flight.

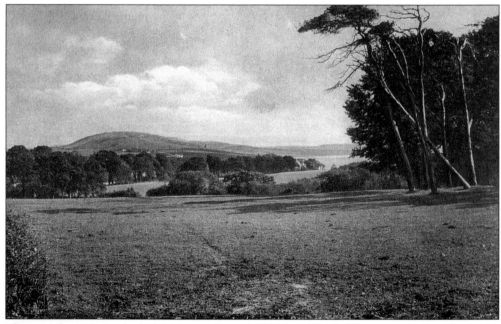

The view from Farringford which so enchanted Alfred and Emily Tennyson on their first visits and induced them to make it their home. In the distance is Afton Down, named after Sir Robert Affeton, Lord of Afton Manor during the 1300s.

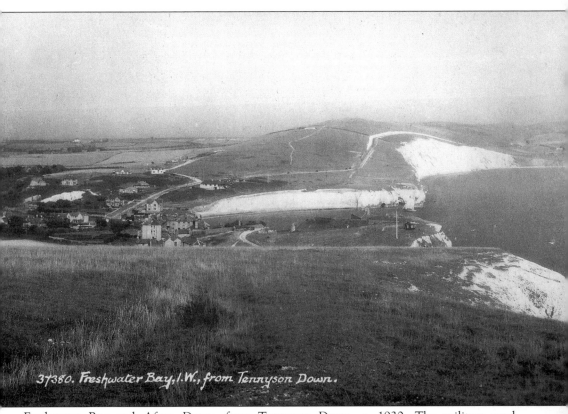

37380. Freshwater Bay, I.W., from Tennyson Down.

Freshwater Bay and Afton Down, from Tennyson Down, c. 1930. The military road, conspicuous above Compton Bay, was built by Sir Charles Seely of Brook, in around 1860, to service garrisons and deploy troops in case of foreign invasion.

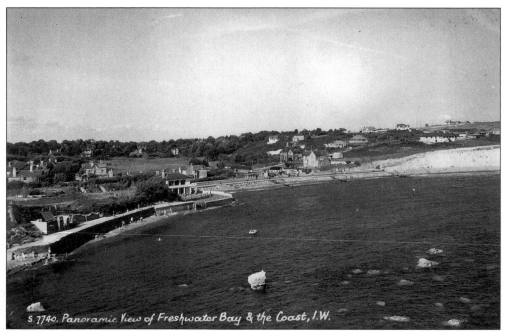

S.7740. Panoramic View of Freshwater Bay & the Coast, I.W.

Another view of Freshwater Bay from the Redoubt fort. The esplanade to the west of the Albion Hotel (visible at the left of centre), can clearly be seen. To the right are the clusters of holiday bungalows on the lower slopes of Afton Down.

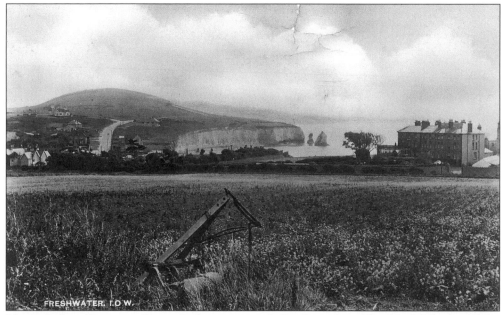

FRESHWATER. I.O.W.

The view from Tennyson Down, looking westward. On the right is Plumbley's Hotel, and the Arch and Stag Rocks are in the middle distance. On the left is the military road, with its first steep climb onto the cliff-top levels.

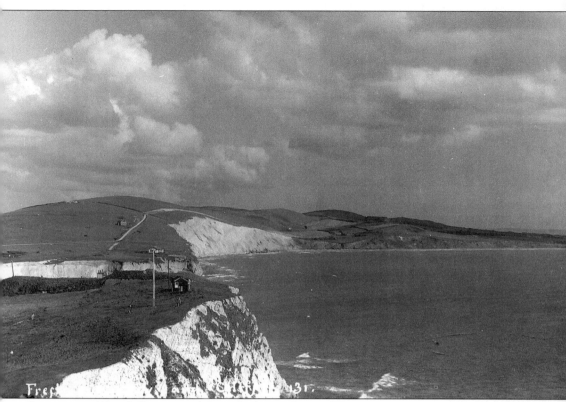

Compton and Brook Bays viewed from the lower slopes of Tennyson Down, *c.* 1930. Note the change from the chalk of Compton to the wealden and greensand of the Brook cliffs. Immediately below, to the right, is the cleft known as Watcombe Bay.

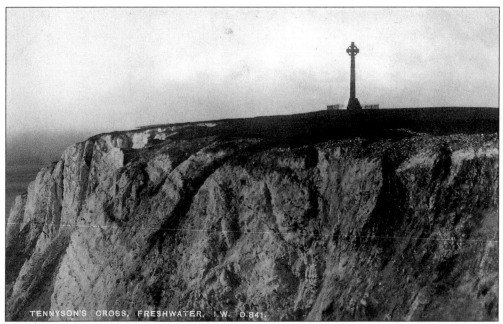

Tennyson's Monument, showing its close proximity to the edge of the 480ft cliffs dropping to the Channel. An older beacon that had long served as a landmark for sailors is illustrated later in the book.

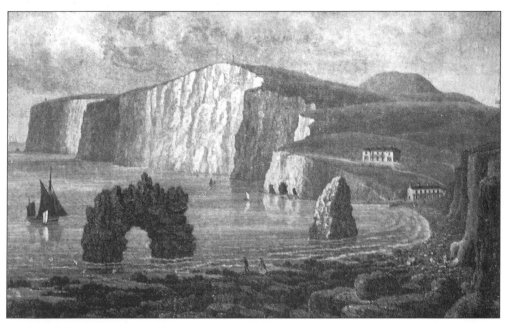

An impression of Freshwater Bay, as engraved by George Brannon in 1840. The Cabin or Albion Hotel, with Plumbley's Hotel above it, are well marked, while in the background are the chalk cliffs of High Down, with the old beacon and Headon Hill beyond.

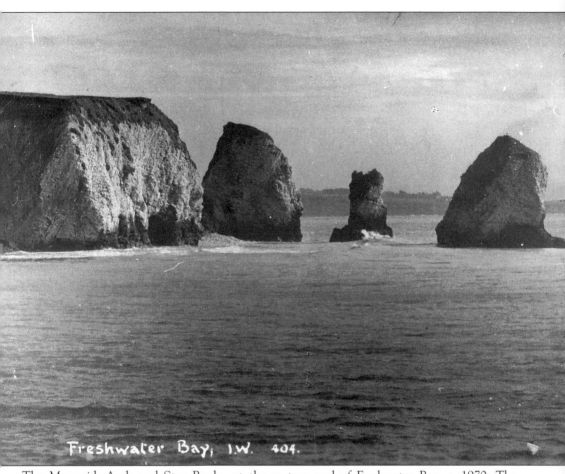

Freshwater Bay, I.W. 404.

The Mermaid, Arch and Stag Rocks, at the eastern end of Freshwater Bay, *c.* 1970. The Mermaid was created during heavy seas one night in 1967. Since this picture was taken, Arch Rock was completely destroyed by heavy storms. Stag Rock is so called because a stag is said to have leapt onto it for safety while being hunted in medieval times. It is sometimes called Deer Pond Rock.

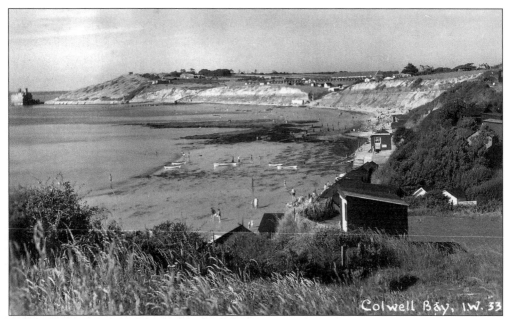

Colwell Bay, Freshwater, photographed by Mr Merwood during the 1950s. The word 'Colwell' means 'the cool spring' – no doubt there was one somewhere in the vicinity.

The view looking west from Golden Hill over the area adjoining the Solent-facing shores of West Wight. Hatherwood Point, Headon Hill and Warren are in the far distance. Right of centre, in the middle distance, the roof of Totland Methodist church is visible.

A peep through the Arch Rock from a cave under the adjoining cliff, just at the turn of low tide.

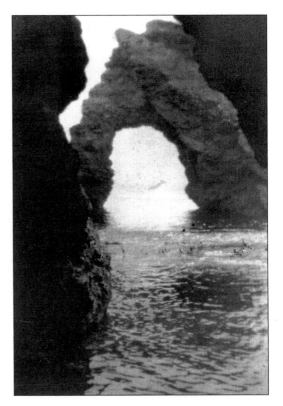

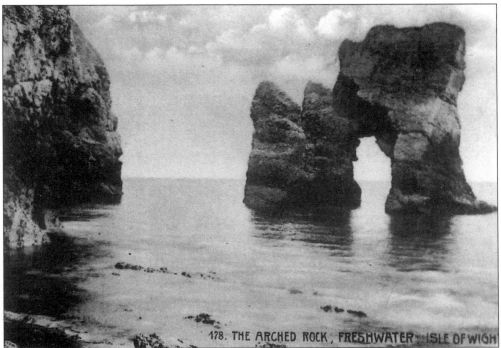

178. THE ARCHED ROCK, FRESHWATER, ISLE OF WIGH

The Arch Rock, Freshwater, taken in 1910. Heavy seas and storms eroded it until the rock finally collapsed in 1992.

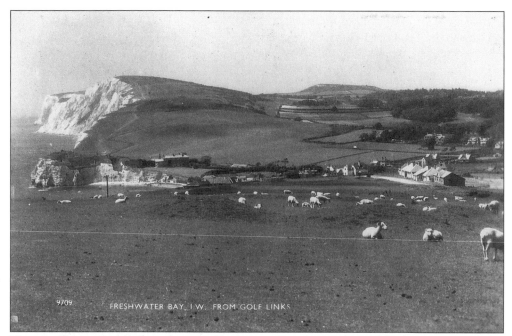

The view from Afton looking down on Freshwater Bay. Across the middle distance spreads the village of Freshwater Gate. In the far distance is Headon Hill.

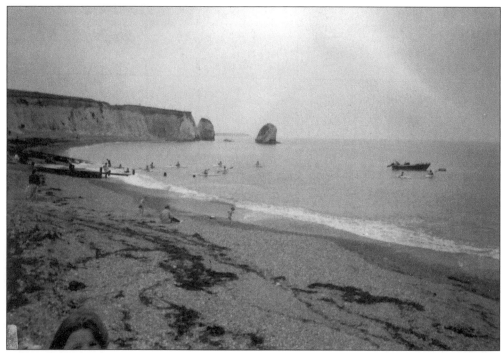

The changed profile of Freshwater Bay after the Arch Rock was swept away by storms in 1992.

94

The old beacon on High Down, just before it was replaced by Tennyson's Cross, *c.* 1897. A reduced-scale replica of the beacon was erected by the West Wight Rotary Club at the foot of the High Down, for the Queen's Silver Jubilee in 1977.

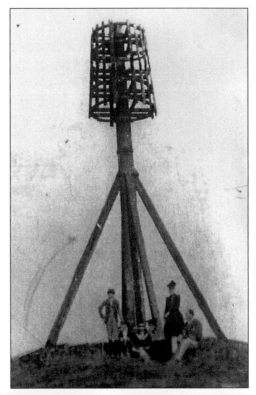

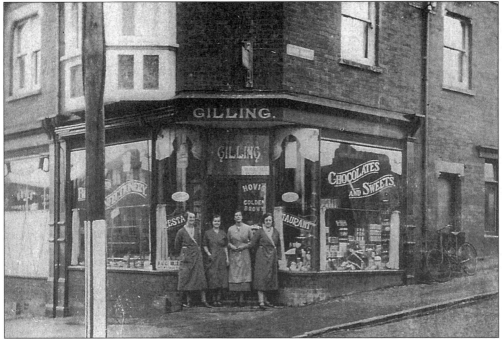

Gilling's shop, Totland. This was a thriving business during the 1920s, comprising a bakery, confectionary and a restaurant. There were branch shops in Avenue Road and Station Road, Freshwater.

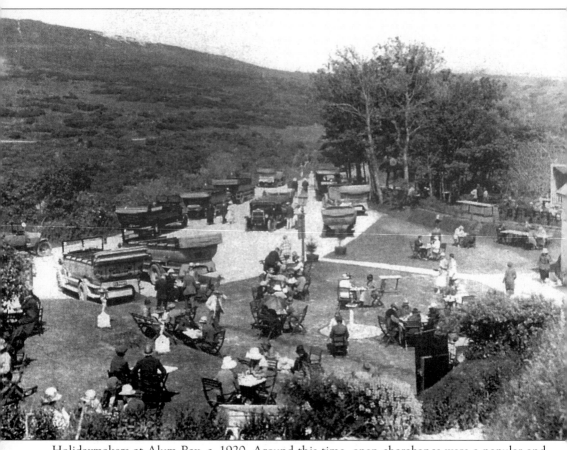

Holidaymakers at Alum Bay, c. 1920. Around this time, open charabancs were a popular and standard form of transport. In the background are the slopes of Headon Warren.

Six
Transport

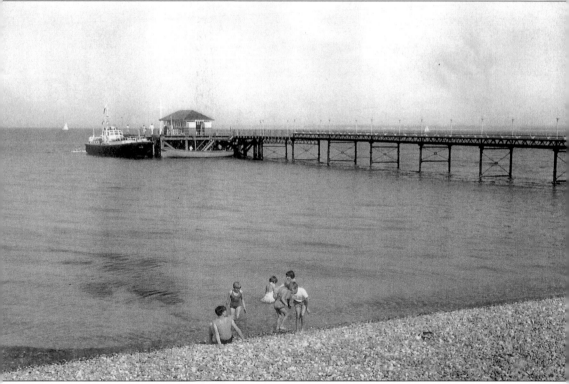

Totland Pier with a motor launch. The pier was once the pride of the bay, providing many attractions for the holidaymakers and a great resort for fishermen.

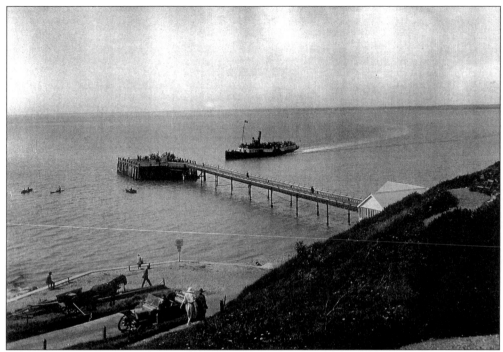

Totland Pier with approaching paddle-steamer, c. 1920. The ferry service from Lymington to Yarmouth would often also call at Totland.

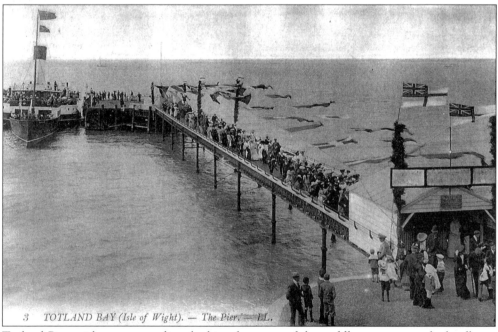

3 TOTLAND BAY (Isle of Wight). — The Pier. — LL.

Totland Pier, with passengers disembarking from one of the paddle-steamers, undoubtedly on one of the special excursions that would operate to Bournemouth during the summer season.

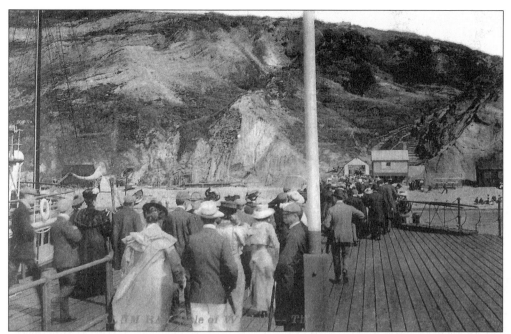

Holidaymakers disembarking from a paddle-steamer at Alum Bay Pier, *c.* 1909.

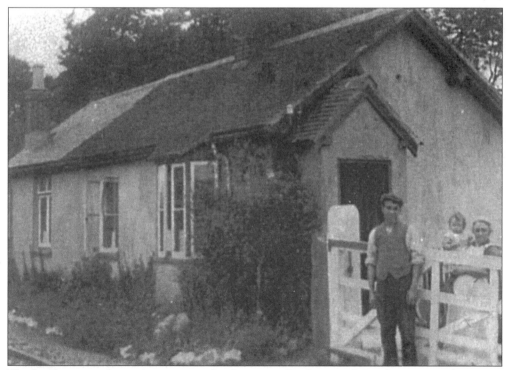

The level-crossing keeper's cottage at the Causeway, Freshwater. Some four times a day, it was his duty to open the gates for the approaching trains. Mr and Mrs Rickman are in the picture.

Yar Bridge and Freshwater Causeway, c. 1912. At one time this was the sole connection between West Wight and the rest of the island. It crosses the Yar at about the point where it ceases to be a freshwater stream and becomes tidal.

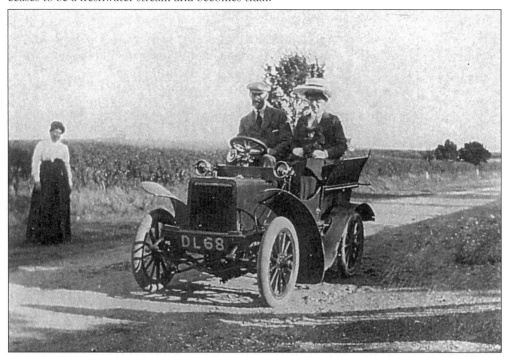

A De Dion motor vehicle making its debut along the roads of West Wight, signifying that the days of the horse-drawn carriage are now numbered.

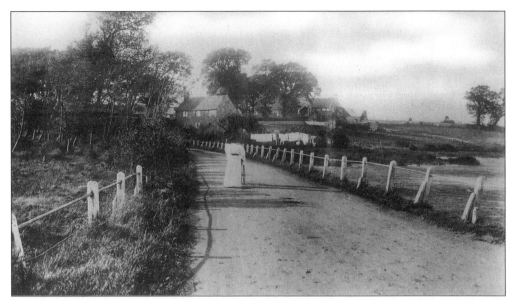

The Freshwater Causeway, c. 1897. This view is looking up the hill towards All Saints church, which is just discernible amongst the trees.

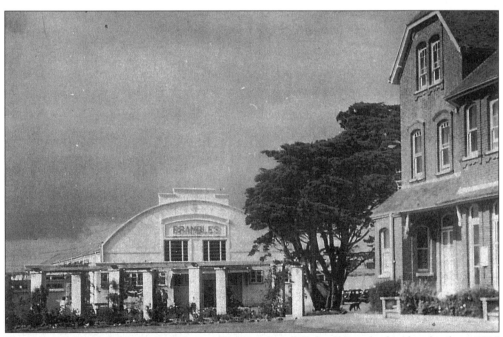

Brambles Chine Holiday Camp, between Yarmouth and Colwell Bay, had its heyday from 1935 until the outbreak of the Second World War, when it was used by the military. The charge for full board was £1 17 6d per week (£1.87). The concert hall and theatre are pictured here.

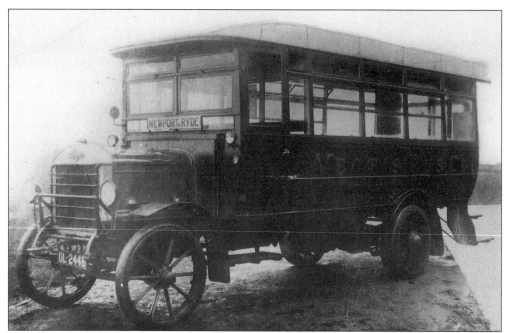

An A.E.C single-decker bus, introduced by the Vectis Bus Company in around 1920. Before that time, many independent operators ran coaches between Yarmouth, Freshwater and Totland to connect with the ferries.

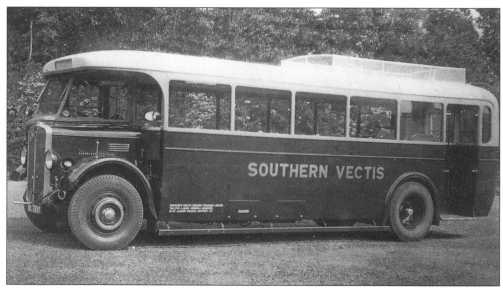

A Southern Vectis single-decker bus of the 1930s. The spread of the bus network did much to spell the end of the island's railways.

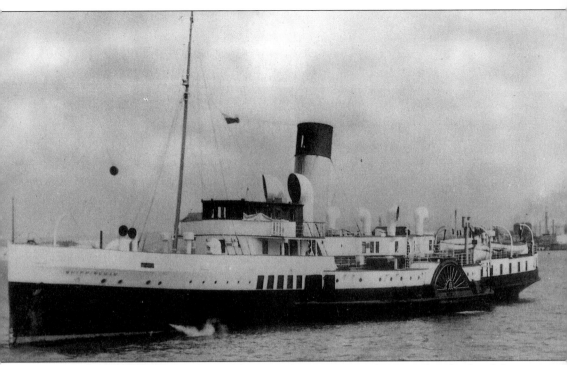

The paddle-steamer *Whippingham*, one of the many ferries operating between the island and the mainland. Such vessels were replaced by motor ferries in the 1950s.

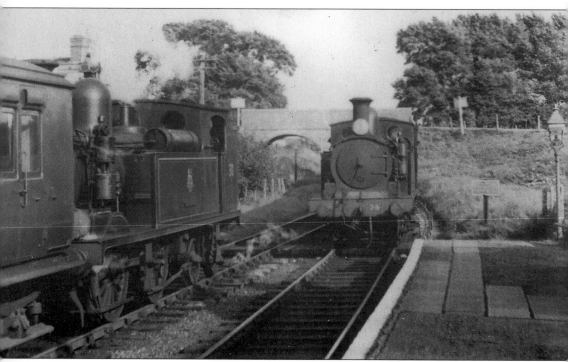

Two trains passing at Ningwood, about two miles west of Yarmouth on the Newport – Freshwater railway. It opened in 1880 and was single track throughout, with passing loops at Carisbrooke, Ningwood and Yarmouth.

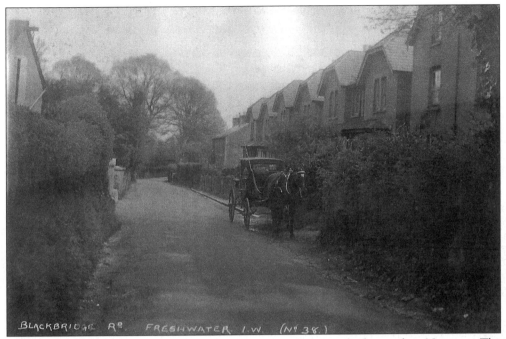

Blackbridge Road, which runs from Gate Lane to connect with the road to Newport. The characteristic gables are a feature of many local villas.

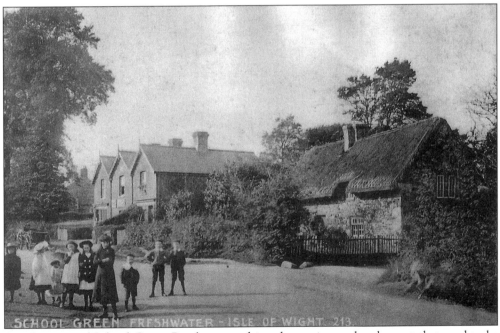

Another part of School Green Road, approaching the station end – the part that used to be called Dove's Lane before the railway came. On the right is the entrance to the bridleway leading to Golden Hill.

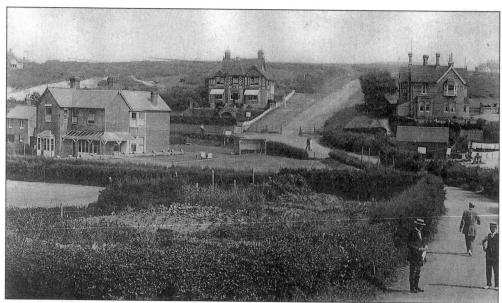

The Military Road, Freshwater. To the left of the foreground is the stretch of low-lying marsh, regarded as containing the source of the freshwater that flows towards the Yar.

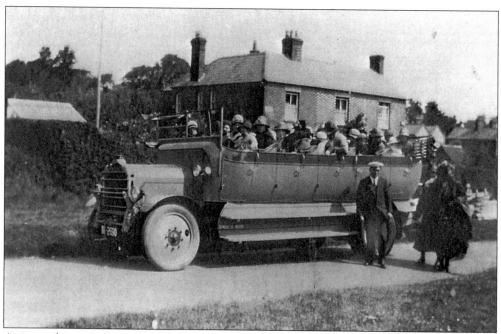

An annual outing about to set off from Norton Green one day in 1925. This excursion was most probably organised by the local mission hall. Such events were an important feature of the social life within the community.

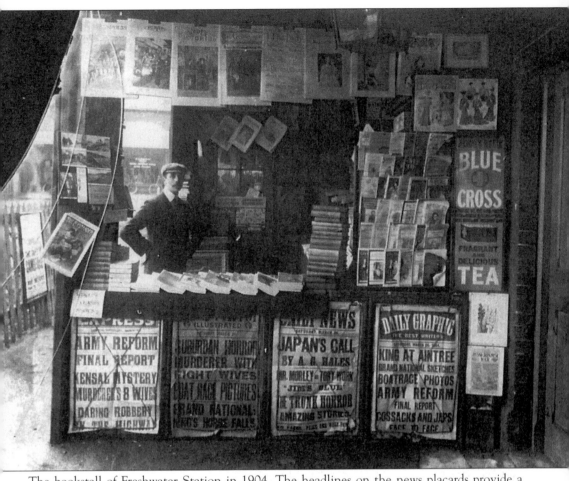

The bookstall of Freshwater Station in 1904. The headlines on the news placards provide a revealing picture of life in those times – not a lot different to today.

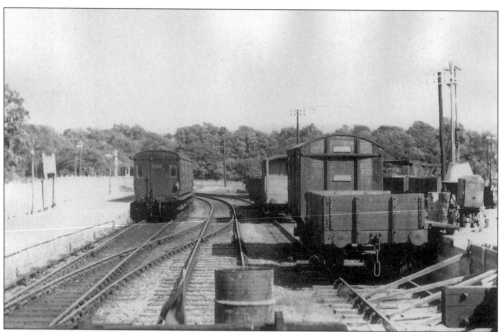

The platform and sidings at Freshwater station, while it was still used as a busy terminal for coal wagons and other freight. The rolling stock suggests the period to be the early 1930s.

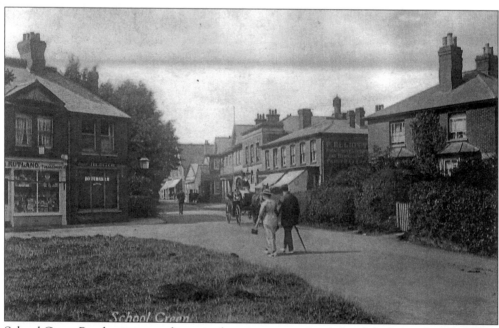

School Green Road as it enters the main shopping centre. Just behind the horse-drawn carriage is the Royal Standard Hotel. On the left, a corner of Moa Place may be seen.

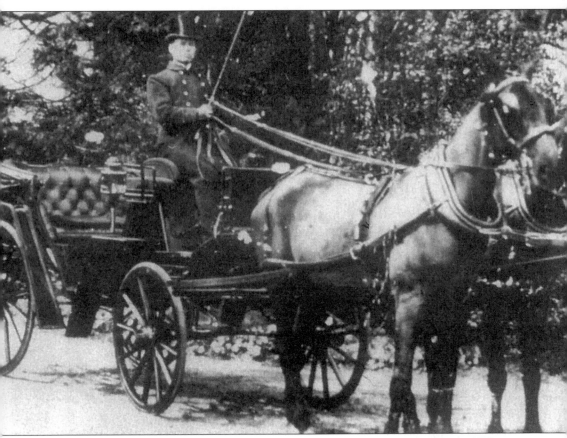

The driver of this carriage is Mr Whitewood, who was coachman to Squire Ward of Weston Manor.

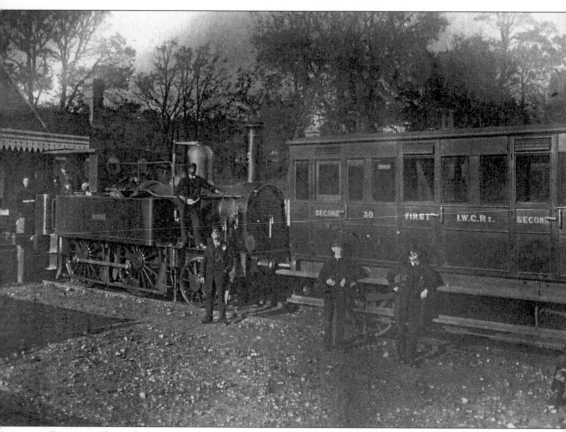

Engine and coach at Freshwater Station, c. 1920. The railway line from Freshwater to Newport was opened in 1889 and worked with stock from the (already existing) Isle of Wight Central Railway. Note the first- and second-class compartments.

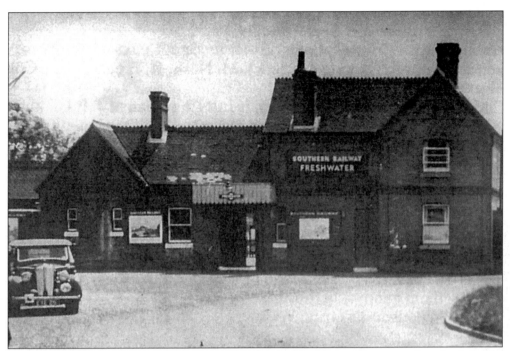

The entrance to Freshwater Station, considered to be the most imposing on the island. In the 1930s, the stationmaster was a Mr Russell, who was paid 16/- per week.

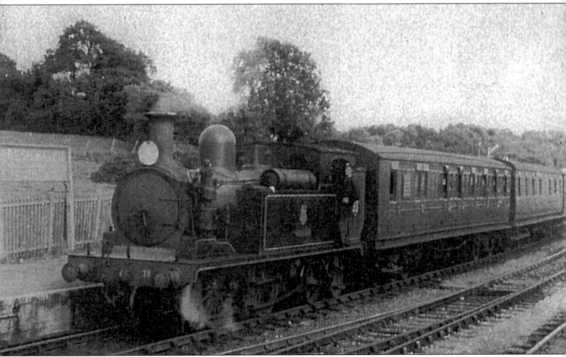

A train arriving at Freshwater from Newport. The engine displays a new 'British Railways' logo, indicating that the period is sometime around 1950. The carriages are ex-Southern Railway mainland stock.

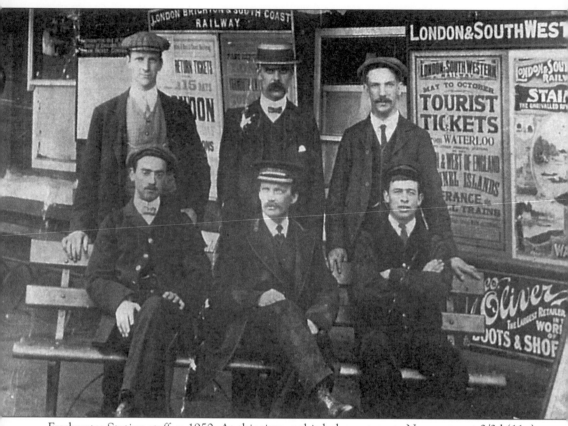

Freshwater Station staff, *c.* 1950. At this time, a third-class return to Newport cost 2/3d (11p).

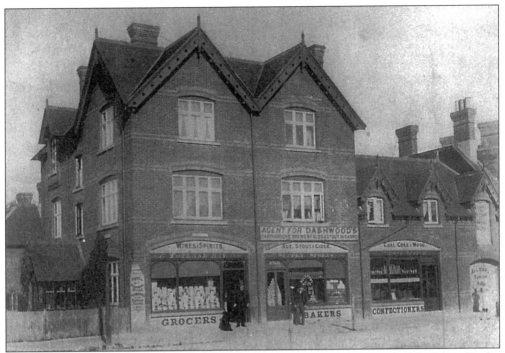

Jordan and Stanley's supply stores in the Broadway, Totland. They retailed Dashwood's ales from Carisbrooke as well as general groceries. The shop was also, for some time, the post office. It has since become the Broadway Inn.

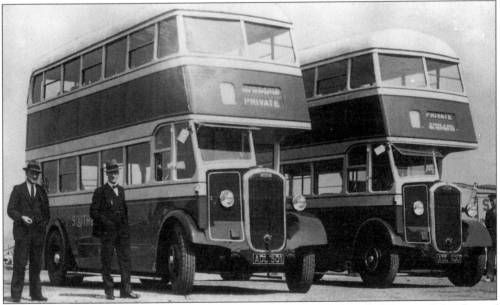

The Southern Vectis Bus Company (as it was renamed in 1929) took delivery of this fleet of Titan double-deckers in 1936. Splendid views of the island's scenery were to be had from the top decks as these buses ambled about the narrow winding roads of West Wight, making this service popular with holiday-makers.

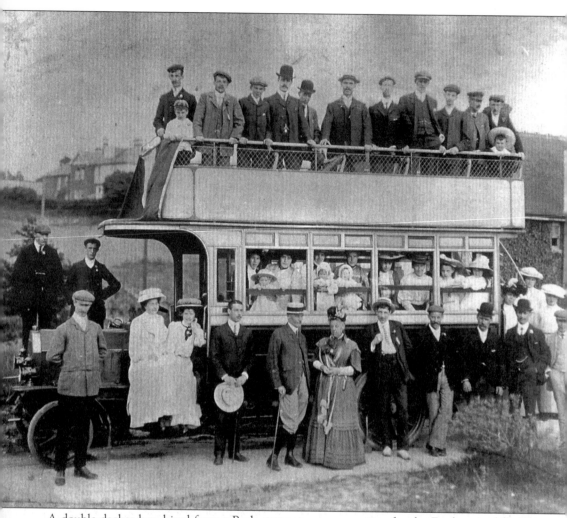

A double-decker bus, hired from a Ryde company, on an outing for the Freshwater folk. The picture was taken in around 1910 by Arthur Kirk of Freshwater.

Seven
Living and Learning

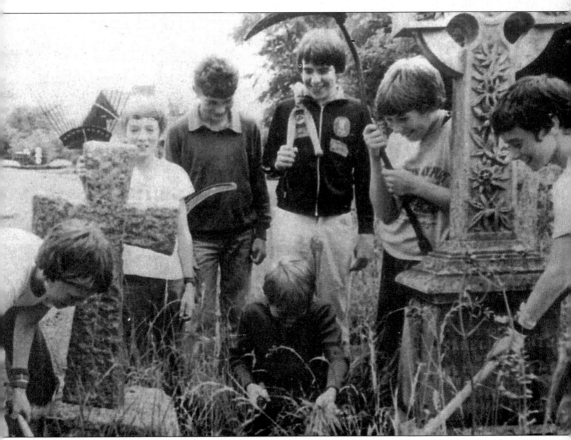

Pupils of the West Wight Middle School tidying up the churchyard at Christ Church, Totland. This was one of the extra-curricular activities of the school, which encouraged service to the community.

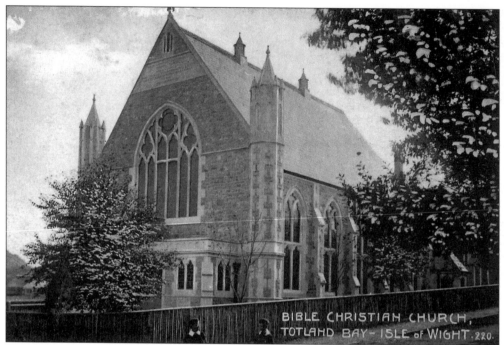

The Bible Christian church, The Avenue, Totland, c. 1910. This church was erected in memory of Mary Toms and William Metherall Bailey, who were recorded as being the first Bible Christian missionaries to come to the Isle of Wight. It is now Totland's Methodist church.

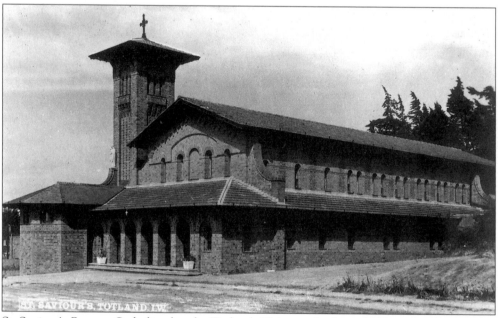

St Saviour's Roman Catholic church, Totland. This was built in 1930 on lands adjoining Weston Manor, with monies bequeathed by the Squire Ward Trust. It replaced a private chapel in the manor itself, which had become too small for the needs of their worshippers.

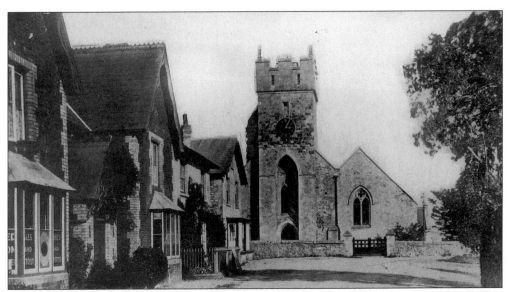

All Saints church, from the west, *c.* 1890. On the left is the Red Lion Inn, which, with its neighbouring cottages, once formed the nucleus of the old parish of Freshwater.

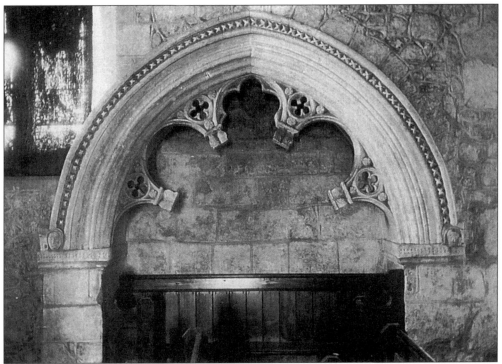

A sepulchral recess in the south wall of the south chantry of All Saints. The cusped arch is of late thirteenth-century detail. It is believed to be the resting-place of Sir Robert Affeton. This picture was taken in 1903.

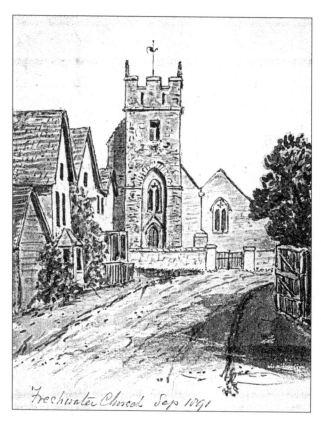

Freshwater Church Sep 1891

All Saints church, Freshwater, from a sketch made in 1891. The building dates from Norman times, replacing an earlier Anglo-Saxon structure. In the eleventh century, William FitzOsbern, Governor of the Isle of Wight, gave the parish to the Abbey of Lyre in Normandy.

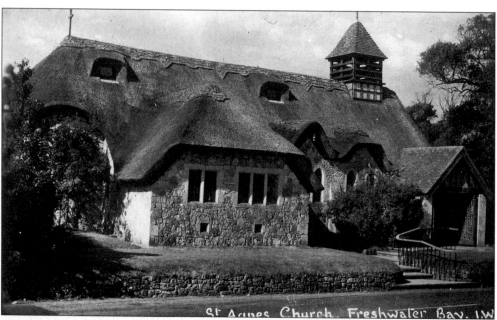

St Agnes Church Freshwater Bay. IW

The famous thatched church of St Agnes, 1912. This was built in 1908 on land given by Hallam Tennyson, the son of the Poet Laureate. It was built to serve the people of Freshwater and also the holidaymakers who flocked to see Tennyson's home.

A closer view of All Saints church and its tower, from the west. The tower dates from the fifteenth century and was erected on a thirteenth-century bell turret. The contrast in the stonework is clearly visible. Little remains of the pre-Norman structure.

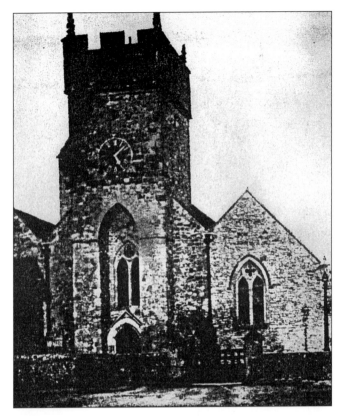

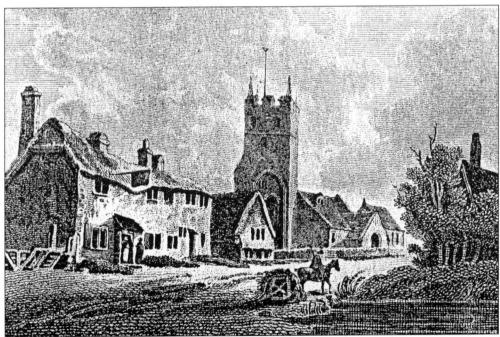

All Saints church from a drawing by L. Hassell (date unknown). The building obscuring the west porch has since gone and the south transept of the church has not yet been added.

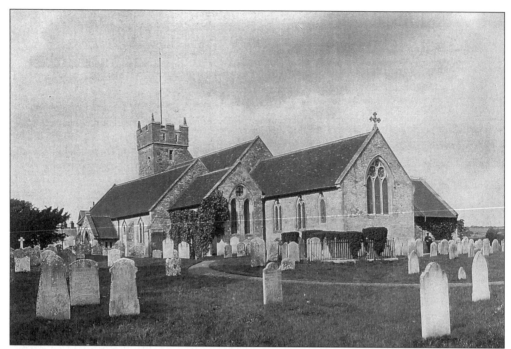

All Saints church from the south-west, taken in 1912. It shows how the church has been enlarged and extended over the years. In the churchyard are the tombs of Emily Tennyson, the wife of the Poet Laureate, and other members of her family.

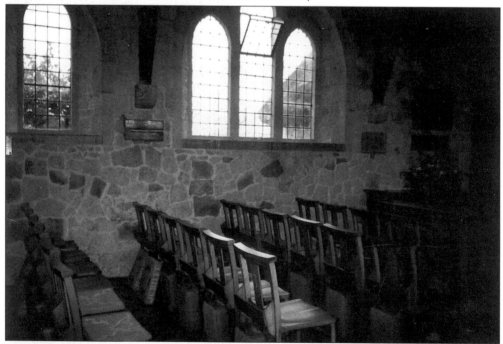

The interior of St Agnes' church. The stone used to build the church came from a derelict house on Hooke Hill. It was designed by Mr I. Jones from a painting by the (then rector) Revd A.J. Robertson.

A memorial window for Richard
Rowland Cross (in All Saint's church)
who died young in 1911. It reproduces a
painting by G.F. Watts, who modelled
the angel on Audrey Boyle, the first wife
of Hallam Tennyson.

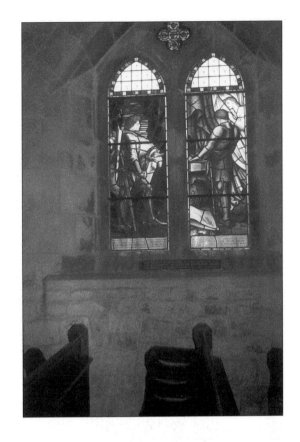

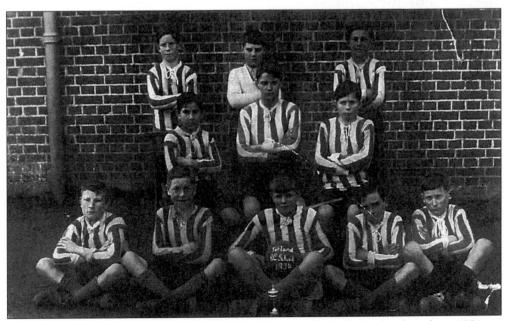

Boys of a football team at St Saviour's Roman Catholic School, Totland, taken about 1934.

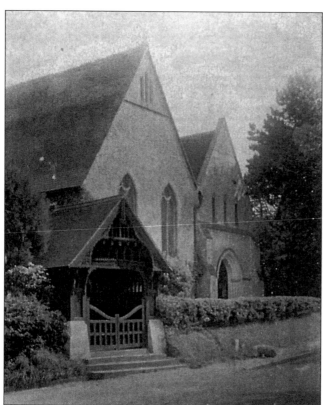

Christ Church – Totland's own parish church. It was built in 1875, on land given by the Revd Christopher Bowen, a local resident. Since 1945, the vicars of Totland act as chaplains to the Needles Lighthouse keepers.

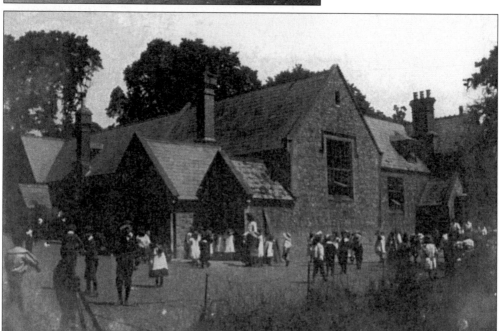

The Freshwater All Saints Church of England School, *c.* 1900. When it was founded in 1850, it was the National School and one of those set up throughout the country under the Education Act of 1841.

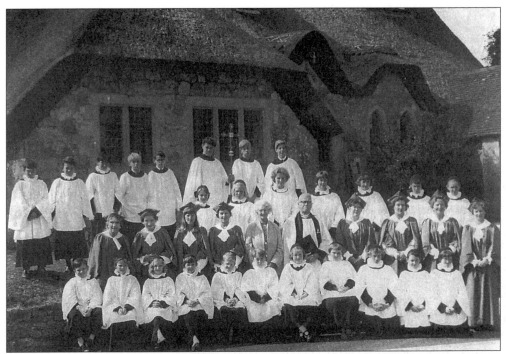

The choir of St Agnes, Freshwater, assembled one sunny morning outside St Agnes' church. Seated in the centre is the rector, the Revd Farnesworth.

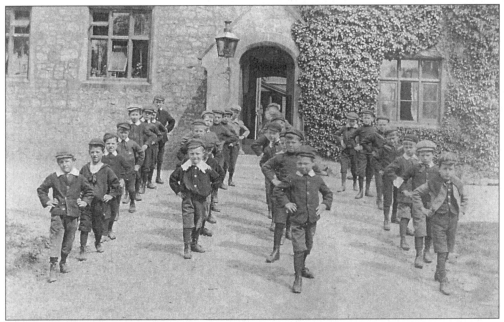

Physical training session in progress at the National School, one morning in 1905. Is this a foretaste of the fashion for line-dancing in the present day? The wearing of school uniform was strictly insisted upon at all times. School fees averaged 2d per week, but varied according to the means of the parents.

A detail of the chapel exterior of Weston Manor. Since the departure of the wards, it has become a home for the mentally handicapped and is run by a religious order.

St Swithin's church, Thorley. Thorley was the original port of entry for West Wight, until the creek upon which it stood silted up. Yarmouth was then built, at the mouth of the river, by Baldwin de Redvers.

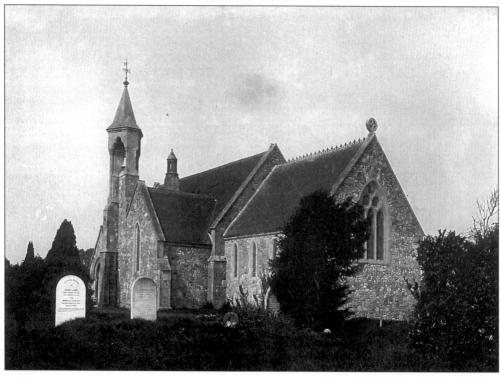

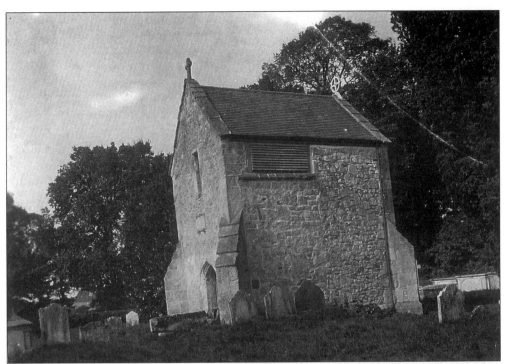

The mortuary chapel of St Swithins, Thorley, viewed from the south-east. It consists of the porch and belfry of the old church. The bells of Thorley church came from Shalfleet, who sold them when in financial straits.

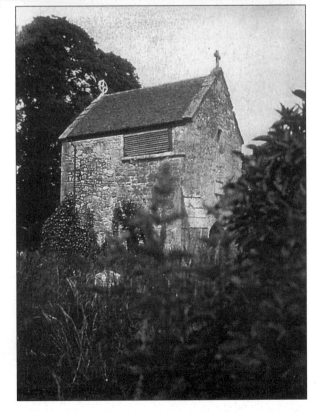

A south-west view of the mortuary chapel of St Swithin's, Thorley. In pre-Norman times, Thorley was called 'Torlei' ('the thorny lea'). This church was built in 1871, long after the original thirteenth-century church fell into disuse.

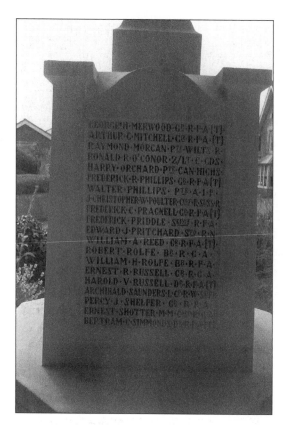

The memorial commemorating both wars, standing outside the All Saints church. This displays the names of members of families that are well-known in the community.

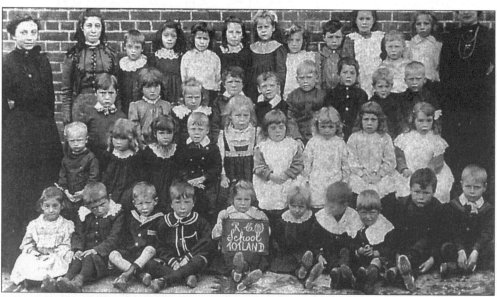

Schoolchildren of St Saviours Roman Catholic School, Totland, c. 1904. The school was founded by Edmund Granville Ward, and housed in cottages he purchased in Weston Farm Lane. Standing on the left is one of the teachers, Miss Katherine Cokes.

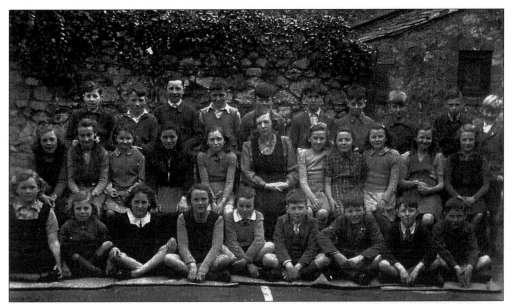

A group of children from All Saints Primary School, Freshwater, *c.* 1946. This photograph was taken around the time when the school-leaving age was raised from fourteen to fifteen. In the centre of the second row is the form teacher, Miss Moyce.

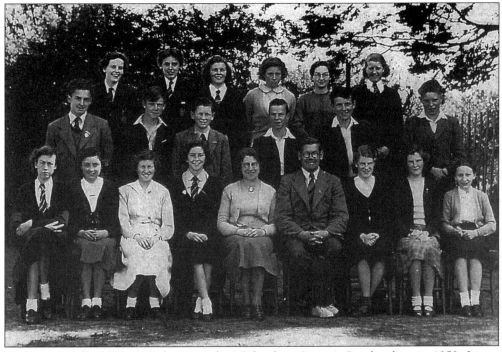

Pupils and staff of West Wight Secondary School in Queen's Road, taken in 1953. It was originally called Freshwater Central when it first opened in 1906.

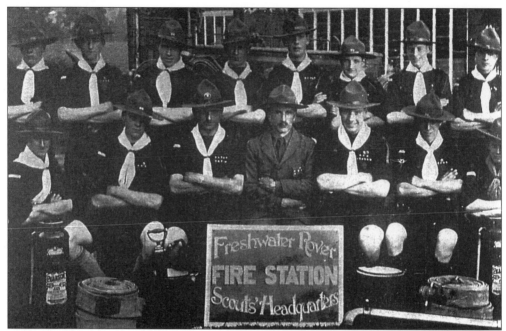

Freshwater Rover Scouts, 1935. They operated a voluntary fire-fighting service for the village, and had their station opposite the school in School Green Road. They played a gallant part in trying to save the Briary in 1934.

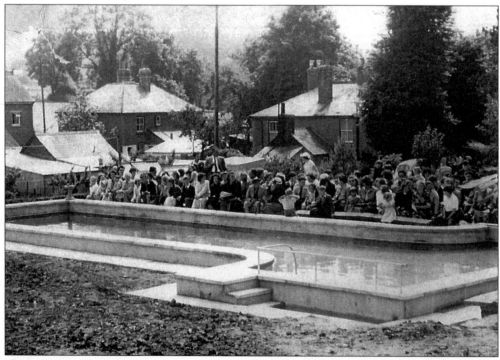

The opening of a new swimming pool at All Saints School in 1958. At that time, the headteacher was Miss K.W. Hammett, who received an MBE for her service on behalf of children's education